# COLORADO MOUNTAIN DOGS

## M. John Fayhee

WESTWINDS
PRESS®

Library of Congress Cataloging-in-Publication Data

Colorado mountain dogs / {compiled by] M. John Fayhee.
       pages cm
   ISBN 978-0-87108-310-4 (pbk.)
   1. Dogs—Colorado. 2. Dogs—Colorado—Pictorial works. I. Fayhee, M. John, 1955-
   SF422.6.U6C645 2014
   636.7309788—dc23
                                    2014004296

Design: Vicki Knapton
Editor: Kathy Howard

Published by WestWinds Press®
An imprint of

GRAPHIC ARTS
BOOKS®

P.O. Box 56118
Portland, Oregon 97238-6118
503-254-5591
www.graphicartsbooks.com

**COVER: Becca**, short for Rebecca Easy-Look, was seven years old when she and her human companion, Jon Feiges, took a trip in Upper Slate Drainage in the Gore Range. On their climb of Peak L., she graciously posed in front of the Trident. Now at thirteen, Becca dreams back to those bygone days, twitches her feet, and stays in the shade.

**CONTENTS: Aiko** contemplating how many sticks he could retrieve in the snowmelt waters of Willow Lake, high in the Sangre de Cristo Mountains. He warmed the soul and brightened the smiles of his human companions, Green Mountain Falls residents Mike and Barrett Weisheipl, for twelve years.

**PAGES 6-7, LEFT TO RIGHT: Emma** came out of a Denver pound. She is a boxer mix who has been lucky enough to spend much of her life in the mountains hiking and running ahead of her human companion, George Edwards. This photo was taken on Independence Pass; **Max** had no choice but to become an outdoor dog because he was banned from the house when human companion Eric Olson of Silverthorne was home. When left unattended indoors, Max ate just about everything and ruined more than one living-room-area rug with Coney-Island-style eating exploits that included: a bag of twenty-one pig's ears, thirteen Clif Bars delicately unwrapped (which Olson himself is unable to do, and he boasts opposable thumbs), and a box of wheat gluten; **Porter** was indeed a Colorado dog, but like his owners he was also a transplant. He was found in New Mexico's Sandia Mountains and, from the looks of the scar on the left side of his face, he had been fending for himself for some period of time. He was rescued by human companions Keary Howley and Heather Loudon-Howley as a year-old puppy/dog from the animal shelter in Albuquerque. The Howleys later moved to Hesperus, where they still reside. The photo was taken by Keary Howley on a hike up the Colorado Trail from Kennebec Pass in the La Plata Mountains. Porter, as per usual, was being stymied in his quest to catch the elusive ground squirrels squeaking and shrieking in the bushes. He looked up in a moment of utter frustration. This was midsummer, after a couple weeks of the monsoon, so the wildflowers were really going off.

For Cali.

Woof.

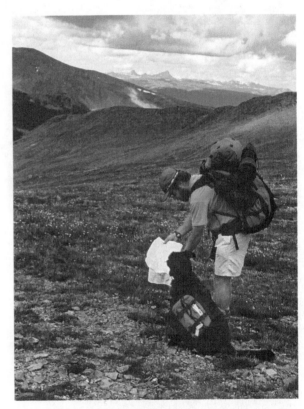

**Cali helps with the orientation process during our two-month traverse of the Colorado section of the Continental Divide Trail. Wetterhorn and Uncompahgre Peaks can be seen in the distance. Photo by Gay Gangel-Fayhee.**

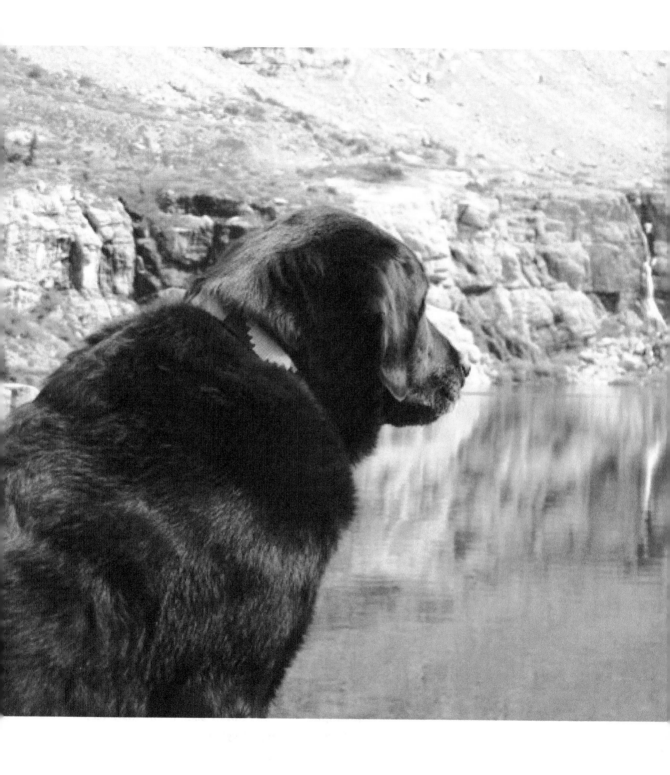

# Contents

"In order to really enjoy a dog, one doesn't

merely try to train him to be semi-human.

The point of it is to open oneself to the

possibility of becoming partly a dog."

—Edward Hoagland

"A really companionable and indispensable dog is an accident of nature. You can't

get it by breeding for it, and you can't buy it with money. It just happens along."

—E. B. White

Though the exact genesis of the *Mountain Gazette*'s first Mountain Dog Issue escapes me, I'm sure it went something like this:

**SCENE:** The deck of the Moose Jaw Bar in downtown Frisco, on a beautiful summer evening. The sidewalks are filled with happy people, most of whom have with them at least one cur. Gathered around a table adorned with numerous pitchers of beer is a motley crew of *Mountain Gazette* employees, all of whom are sweaty and thirsty from their various recently concluded forays up into the surrounding vertical topography.

**(ASSOCIATE PUBLISHER) Alan Stark,** while not-so-subtly eyeballing a comely vixen sauntering by with two pedigree golden retrievers named Alpine and Tundra or Ben and Jerry or Tao and Buddha or some such: "When I come back, I want to be reincarnated as a Colorado mountain dog. Life for dogs in the High Country is generally nothing but skiing, swimming, hiking, chasing sticks and tennis balls, and playing with other dogs."

**(EDITOR & PUBLISHER) M. John Fayhee:** "When you come back, it will probably be as a dung beetle, but, if you change your ways, there might be hope."

**(ADVERTISING DIRECTOR) Jim Marsh:** "Sometimes I think there are more dogs in the High Country than there are people."

**(SALES ASSOCIATE) Chris Hickey:** "I must have passed 200 dogs on the trail while mountain biking today."

**(ART DIRECTOR) John Glover:** "It's like buying a Subaru Outback . . . as soon as people move to the mountains, they think they must have a dog. It's like an accessory."

**Stark:** "Yeah, but you gotta admit that dog culture is one of the coolest aspects of the Colorado Mountains. Nowhere else are humans and dogs so interconnected. It's like dogs and their people are symbiotic species joined at the hip while simultaneously enjoying life at altitude."

*Pause while everyone there gathered sips beer while trying to translate Stark's multi-syllabic verbiage into basic mountain bar-speak.*

**Marsh:** "Maybe we should consider doing an issue of the *Mountain Gazette* totally dedicated to dogs."

**Glover:** "We could ask readers to send in their favorite dog photos. They'd undoubtedly let us use them for free. We could fill the entire magazine with material we don't have to pay for."

**Hickey:** And I'll bet we could sell advertising around those photos. We could offer prizes. Companies that make dog gear would eat it up."

**Stark:** "And we could get our regular writers to pen dog stories to go with the photos. It would be a very cool issue."

**Fayhee,** trying to simultaneously drink beer while mentally sussing out the math—beaucoup free editorial material + the potential of making extra money from selling ads to dog-gear companies + undeniable coolness factor ÷ what will almost certainly amount to one serious truckload of extra work: "Gulp. Sigh."

No matter its actual conceptual roots, in 2006, *Mountain Gazette* issued a call for photographic submissions for our first-ever Mountain Dog Issue. I held my breath and awaited the pixilated tsunami, which arrived in short order and lasted way longer than tsunamis usually do. When the waters finally receded, I found myself staring at almost 500 dog-photo submissions, many of which included unrepentant pleas, entreaties of various sorts, and outright bribery that covered several captivating categories.

Though I had rightfully predicted that we would receive an inordinate quantity of submissions, I did not take that prediction one step further, to its logical conclusion, prior to facing down those 500 photos: I had devised no plan for selecting which photos would appear in our pages. I ought to have lined up several luminaries to serve as judges. I ought to have lassoed a herd of my drinking buddies.

I ought to have done something, *anything*, to before-the-fact extricate myself from the increased workload I suddenly found myself facing. But I did none of those things. As a result, I not only had to make my way through that mountain of figurative celluloid, but I had to simultaneously devise criteria for selecting the photos that would eventually appear in the *Gazette*'s pages, which had room for only forty or so dog photos.

What I eventually did was concoct numerous artificial categories based upon impressions that leaped out from those photographs. Stuff like "dogs with snow on faces" and "dogs lifting their legs in places they shouldn't" and "tongues" and "pose" and "action." Even with these categories, it took me weeks and weeks to pick winners, many of which were chosen essentially by me throwing darts and choosing whichever photo got hit.

When the issue finally the hit streets, we were inundated with praise and requests to make the Mountain Dog Issue an annual event.

Gulp. Sigh.

But "gulp/sigh" with a proviso: Despite the stunning amount of time and effort that went into getting that first Mountain Dog Issue out the door, it was, needless to say, a very pleasant and amusing experience. I mean, I've dug ditches; I've hacked my way through dense Southern foliage with a machete; I've done grunt farm labor. So I know full well that, when the worst thing you have to do when you arrive at the office is thumb through a stack of photos depicting dogs cavorting in the mountains with their smiling people, your life doesn't suck.

One of the main reasons we received so many submissions for our first Mountain

Dog Issue was that some bonehead who shall herein remain nameless did not think to limit the number of photos each person was allowed to submit. While many people were considerate and humble enough to send in only one or two images of Fido standing there looking silly with his tongue hanging two feet out of his mouth, the vast majority apparently had no qualms whatsoever about sending in entire photo albums of Fido standing there looking silly with his tongue hanging two feet out of his mouth.

The second Mountain Dog Issue, I asked that people only send in two photos per dog. Even with that restriction, we still, once again, received more than 500 dog-photo submissions, at least partially because a whole lot of folks did not heed my two-photo rule and at least partially because many mountain folks own more than one dog and at least partially because, by 2007, Word Had Spread.

The call for submissions to our third-annual Mountain Dog Issue contained no-nonsense wording: By God, NO MORE THAN TWO PHOTOS PER PERSON SUBMITTING!!! I stressed that, this time, I would be brutal. This time, I would summarily delete anyone not heeding my unambiguous dictum. What I did not consider before the fact was that, often, the husband would send in two photos of Fifi, then the wife would send in two more photos of Fifi, then each of the kids would send in additional photos of Fifi. Once again, we got more than 500 submissions.

And so it went, for five years, clear up until the owner of the *Mountain Gazette* decided to shut the magazine down for reasons that had nothing whatsoever to do with the annual Mountain Dog Issue, which was so popular, we actually had to print thousands of extra copies.

All told, over the course of those five years and five Mountain Dog Issues, we received more than 2,500 dog photos.

I saved almost every one of those photos, for reasons that had more to do with sentimentality than they did with practicality. Then, one day, out of the blue (probably while I was sitting on the deck of the Moose Jaw), the idea of producing a mountain dog book based upon *Mountain Gazette's* Mountain Dog issues germinated, gestated, and finally sprang from my mental womb.

It sounded like a worthy idea, and the good folks at WestWinds Press®, which had previously published my *Colorado Mountain Companion* book, agreed.

So, with the idea of trying to organize a mountain dog book, I began to revisit those 2,500 mountain dog photos, many of which, regrettably, contained nary a syllable of saved contact information. The thought of retaining the e-mails by which those photos were originally delivered to my inbox never entered my head those first two years. So, almost 1,000 dog photos—many of them very good—got culled almost immediately because, for legal reasons, I felt compelled to ask people if it would be OK to use their photos in the book you now hold in your hands.

That left about 1,500 photos—still a lot of material from which to choose. Based upon sheer palpability, we—the publisher, the editor, the art director, and yours truly—decided to focus this book solely on Colorado mountain dogs. That was a tough call, but it does open the possibility of producing a mountain dog book that covers a larger geographic area somewhere down the road. That decision essentially halved the number of photos open for consideration. The number was further cut by a third because much of the contact information attached to the photos was outdated. I tried using social media to hunt down some of the folks whose e-mail address I had on file was no longer current. A couple of the people had apparently moved out of the country with no forwarding address. A couple had apparently passed away. Several had changed their name for reasons I did not care to pursue. A few simply did not respond. And one replied with a cryptic note about getting back with me once he's off parole.

So, I began to piece this book together with a workable pool of maybe 500 photos and room for about 160. I decided early on—at least partially because I had no money to pay people to use their images—to really try hard to use no more than one photo per person, and, with limited exceptions, I adhered to that self-imposed edict. I also decided that I wanted to cover as many broad spectrums as possible. I wanted big dogs and little dogs, identifiable breeds and mutts, summer and winter, water and snow, scenic vistas and portraits, naked women and clothed women (just kidding!), action and repose, hiking, climbing, skiing and paddling, the San Juans, the Flatirons and the Dunes, Steamboat Springs, Crested Butte, Leadville and Boulder, in-bounds and out of bounds. (Sometimes, *way* out of bounds.)

Here's the main thing about selecting dog photos for publication, a subject of which I feel I have become something of an expert: In my mind, there is no such thing as a bad dog photo. There might be dog photos that are not professionally composed, that are a little out of focus, that did not manage to successfully mate f-stop with shutter speed. Despite all that, I repeat: there are no bad dog photos. And because there are no bad dog photos, I was very open to including within these pages shots that were not professionally composed, that are maybe a little out of focus, that did not manage to successfully mate f-stop with shutter speed. There are few things I know enough about to comment without sounding like the idiot I surely am otherwise. One of those things is the sociology of the Colorado High Country. That intimacy allows me to understand clear down to my marrow that one of the best things about the sociology of the Colorado High Country is that it continues to be dominated by circumstances that are not professionally composed, that are a little out of focus (well, sometimes a *lot* out of focus), and that are not successful matings of things like f-stop and shutter speed.

At the same time, Colorado's mountain country is home to many photographers who actually boast pedigree, who not only know how to mate f-stop and shutter speed,

but who know how to do so while purposefully integrating concepts such as depth-of-field and the rule of thirds into their creative endeavours. This book contains ample examples of work from people who make their living with a camera.

I am absolutely delighted that *Colorado Mountain Dogs* contains a mix of both professional work and the photography of folks who, like me, cross their fingers every time they pull their camera out of their pack.

The single biggest question that reared its head while I was choosing which photos to include in this book was the most obvious: What exactly constitutes a "Colorado mountain dog?" The apotheosis, naturally, is a dog that was born and raised in the Colorado mountains, that still lives (or lived) in the Colorado mountains, and has human companions who were born, raised, and still live in the Colorado mountains and who took a photo of their dog in a Colorado mountain setting. Those, of course, went to the top of the list. But they did not define the list. Herein you will find photos of dogs that live in other states that were photographed while visiting the Colorado mountains. You will find dogs that live in Colorado that were photographed while traveling to other locales. You will find photos of dogs that once lived in Colorado but no longer do. And you might even find a photo or two of dogs that, when push comes to shove, really have only the most specious relationship to Colorado, like, for instance, their human companion once drove through the Centennial State at a high rate of speed while evading capture.

In other words: I made sure that this book remained as pure as possible without asking to see birth certificates and driver's licenses.

Two more things:

First, I asked all human companions whose photos were being considered for inclusion in this book to pen a few lines about the dog and/or the photo. (I was going to ask the dogs themselves to pen those lines, but most were too busy rolling in the mud to be bothered.) Some folks responded with nut-and-bolts—the dog's name, their name, and where the photo was taken. Some folks responded with a combination of an Ancestry.com-like history of their dog's lineage, a detailed curriculum vitae of every hike their dog has ever taken, every stream their dog every drank from, and every crap their dog ever took, as well as a PhD–level dissertation on the geologic evolution of the Colorado mountains themselves. Then there was Summit County photographer Bob Winsett, whom I have known for many years, who submitted an entire original poem. Naturally, I had to edit and reconfigure some of the more verbose submissions. Still, some are longer than others. Some are actually at least as interesting as the photo those words accompany.

Second: Being a man of words more than a man of images, I decided to ask some of my dog-owning writer chums to pen dog-related essays for inclusion in this book. Since the remuneration consisted only of vague promises of future beer, the only condition I laid on those writers took the form of a plus-or-minus word-count limitation. Other

than that, I offered those writers the chance to cover whatever conceptual ground they desired. So, as you will see, there was not much in the way of editorial coordination on my part vis-à-vis those essays. They are delightfully all over the place, which, in my opinion, is perfectly apropos, because, when it comes to Colorado mountain dogs and their human companions, you're dealing from the foundation up with a concept that is also all over the place, that covers a lot of conceptual ground, and that is not always very well coordinated. Which is exactly how it should be.

I hope you enjoy this book as much as I enjoyed working on it. And I also hope that, when you enter into your next relationship with a dog, you do so at your local animal shelter or rescue group.

I hope you will donate time and money to your local animal shelter or rescue group. And I hope that when you see a dog sitting on a street corner by itself or running through the woods unattended, you will take the time to help that dog find its way back home.

—M. John Fayhee

**Libby was an abandoned stray that was found at a park in California by human companions Laurie and David Lester when she was just a puppy. Libby made Marley look like an angel. Libby at one point made a meal of an entire beach towel. She mellowed with age and enjoyed going on little excursions with the Lesters, who own the Willow Pond Bed & Breakfast in Grand Junction. This photo was taken on the Grand Mesa by Dave.**

# Acknowledgments

As I mentioned in the Introduction, every person who contributed photographs to this book (there are too many to list) did so without compensation of any kind. I cannot overstate my heartfelt gratitude for that generosity.

As well, the people who contributed essays did so out of the kindness of their hearts and because, more than anything, they love dogs. Gracias, amigos.

An extra tip of the hat to Mark Fox, a longtime photographer with the *Summit Daily News* in Frisco, for once again going above and beyond the call of duty by providing photos, as well as providing insights about how people can improve their mountain dog photography.

Thanks too to David Pfau, proprietor of Breckenridge Photographics, for also providing insights regarding successful dog photography.

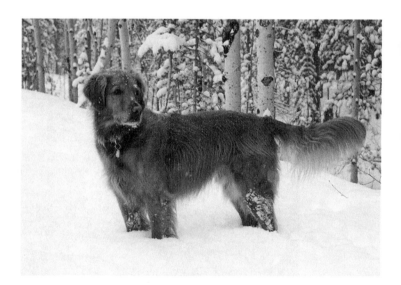

**Scout was one of three littermates—the other two being Maya and Pancho—that were well known in Summit County for more than a decade. Scout's human companion was longtime *Summit Daily News* photographer Brad Odekirk, who passed away tragically in 2006. Scout followed his daddy into the hereafter a couple years ago. Photo by Frisco resident Mark Fox.**

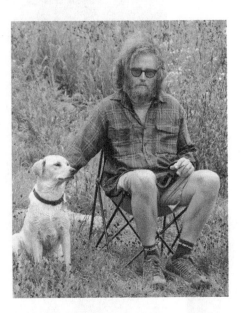

**M. John Fayhee and Casey, a rescue dog saved from death row by Luvin' Labs in Albuquerque, New Mexico.**

M. John Fayhee, who worked as a newspaper reporter and editor for fifteen years, was a longtime contributing editor at *Backpacker* magazine. His work has appeared in *High Country News, ForbesLife MountainTime, Aspen Sojourner* magazine, *Outside, Sierra, Sports Illustrated, USA Today, Men's Fitness, the Walking Magazine, Adventure Travel, Family Camping, New Mexico Magazine*, and many other local, regional, and national publications.

Since it seems in vogue these days for writers to show that they once got their hands dirty, Fayhee has worked as a ditchdigger, house painter, land surveyor, tennis instructor, cook, night watchman on a Mississippi River paddle-wheeler, and truck driver for a juvenile-delinquent-rehabilitation outfit that was seemingly modeled after a Stalin-era Soviet gulag. Fayhee, whose travels have taken him to five continents, earned his Tae Kwon Do black belt in 1995. He has hiked the Colorado, Arizona, and Appalachian Trails, as well as the Colorado section of the Continental Divide Trail. He has stood atop the summits of twenty-seven of Colorado's Fourteeners, but has since repented and promises to stand atop no more.

In 2000, along with two partners, Fayhee helped resurrect the iconic *Mountain Gazette*, where he worked as editor for thirteen years.

After twenty-four years in Colorado, Fayhee moved back to his old stomping grounds in New Mexico's Gila Country, where he lives with his wife, Gay, his dog, Casey, and his very weird cat, Tucker, who wonders why he's not working on a book about mountain felines. Actually, Tucker is too lazy to give a crap about anything save her next meal.

# best at hiking

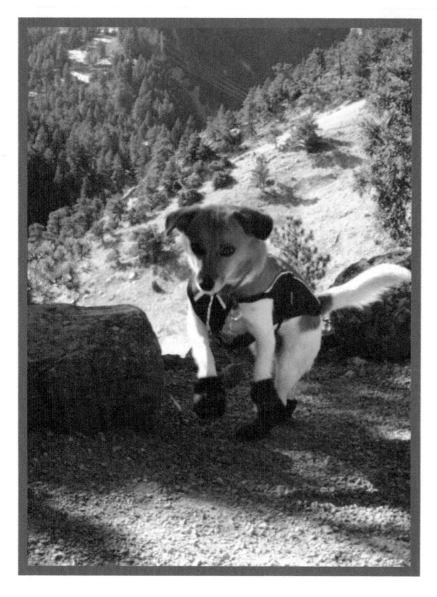

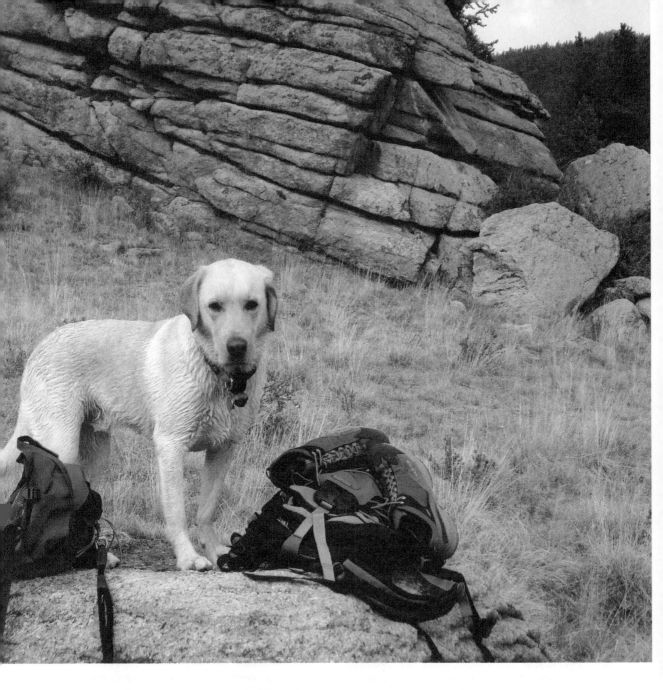

◀ Chico was brought to Colorado from Costa Rica ten years ago by human companion Sue Meyer. His evolution from street dog has been amazing. He is now therapy trained and visits patients in the hospital as well as hangs out with his roommate, a goat named Jupiter, and rides on the back of Meyer's bike.

▲ Bulluck, rescued from the Larimer County Humane Society and resident of Frisco, out on a backpacking and fly-fishing trip in the Lost Creek Wilderness. Human companions: Melissa and Christian Sherburne.

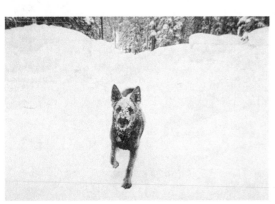

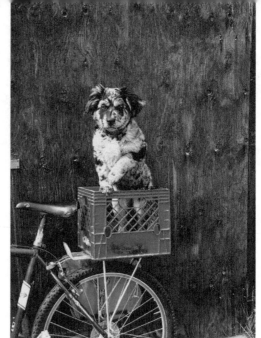

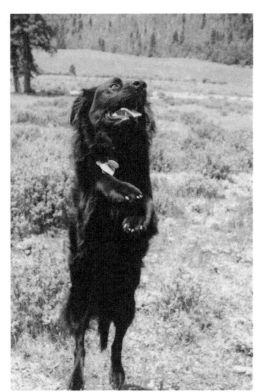

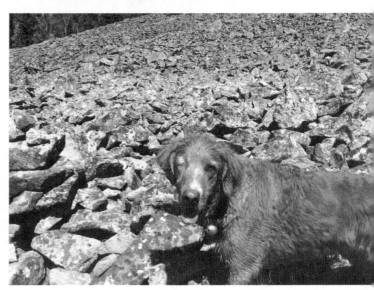

**TOP LEFT** Yampah with a festive winter face shot as he is frolicking up Boreas Pass Road during an epic snowshoe adventure with human companions Tom and Paige Scheuermann. **TOP RIGHT** Stella Blue was so named partly because her companion, Amanda Good, is a Deadhead, but also because Stella is part blue merl Australian shepherd. As a pup, Stella would ride in the milk crate on the back of Good's commuter bike. The photo was taken in Leadville. **BOTTOM LEFT** Maisie, a border collie mix, in her stomping grounds, the San Juan Mountains. Human companion Jackie McManus adopted Maisie from the Humane Society in 2003, and Maisie spent the next nine years exuding gratitude and loyalty. Whether racing to the top of Engineer Mountain, rafting down the Colorado River, browsing books at Maria's Bookshop in Durango, rolling in snow, keeping tabs on the neighborhood cats, or getting skunked, Maisie lived life to its fullest. She passed away in October 2012. **BOTTOM RIGHT** Mack the Rogue looks on with his one eye in scree somewhere above Rico. Losing the right eye to a sudden glaucoma didn't slow this guy down—he perfected his trail running with human companion Gretchen Treadwell all throughout the San Juan Mountains.

**TOP LEFT** Moose digging in the freshly fallen snow, looking for one of the bones he buried the previous summer on the property of his human companions, Bob and Jean Kane, in Florissant. **TOP RIGHT** Star and Skye were asked by their human companions, Jamie Colledge and Gayle Bush, to look threatening and guard camp near Rainbow Lakes in Boulder County. This is what they came up with. **BOTTOM LEFT** Zippy is a cattle dog cross that was found in the Superstition Wilderness of Arizona. Human companion Cheryl Sandridge took the photo early one morning looking west toward the Lost Creek Wilderness. While many are saddened by the Hayman Fire aftermath, Sandridge enjoys the long views offered and the slightly surreal revealing of the naked mountain aspect. **BOTTOM RIGHT** Napi, nee Spike, was rescued from the Blackfeet Indian Reservation near Babb, Montana. As his best bud—Sara "Noodle" Boilen—crested into her thirtieth year of life, the pair hiked up Mt. Morrison, near the famed Red Rocks Amphitheatre, to see the sun rise. What was meant to be a cheesy self-timed portrait became something much greater when Napi, covered in alpenglow, entered the frame moments before the shot.

# Partnering with a Border Collie  By George Sibley

**B**arring strange accidents or chance, I've partnered with my last dog—mostly because my last dog was such a superior partner.

She was a border collie, Zoe; and Zoe was actually the only dog I've ever really been invited to partner with, however unworthy I was at it. There were a couple other dogs in my life when I was a kid, but they were just family pets. Bred for petdom. Border collies aren't bred to be pets; they are bred for intelligence and bred for work, and they more or less insist on—I would say, deserve—a working partnership. And my partnership with Zoe was not really a "fulfilled" partnership because I didn't really have any work for her to do that was worthy of her skills and willingness.

Our daughter brought her into our lives; Zoe was a gift from her godfather, Steve Allen, a rancher over in the valley of the North Fork of the Gunnison who, for a time, raised and trained border collies on the side. Then Sarah went away to college three years later, and my (human) partner and I inherited Zoe, for what turned out to be the rest of Zoe's life (fourteen years total).

What border collies can do in a working situation is impressive. "Sheep dog trials" are held around the country, to show off the skills and intelligence of these dogs. My (human) partner and I went to the trials up in Meeker, Colorado, once, to watch the human-and-dog teams work through an almost fiendish set of challenges, that begins with sending the dog out full speed on a quarter-mile circling run, to move a small herd of semi-wild sheep down through some slalom-like gates, and ends with some very complex penning challenges involving splitting the flock to separate out some with colored bandannas.

The champion dogs at the Meeker trials are often older females: They can still turn on the "berserker" look—wild-eyed, teeth and tongue panting like a furnace, moving in a crouch as if about to spring—that gets the sheep moving, but they've settled down to work, and have worked so long with their human partner that one could swear they are reading each other's minds, and that may not be too far from the truth. Steve Allen said the biggest challenge for the dog's partner is not distracting the dog with too much instruction.

We of course had nothing in our towny lives to provide any comparable work for Zoe. Not that moving stock is the only kind of work they find acceptable: border collies can be good babysitters; they are used in search-and-rescue work; they are good in hunting; they are great Frisbee-catchers; and they will keep your yard cat-free. They've been recruited for therapy and assistance work for people with disabilities; one border collie became the "hearing-ear dog" for a woman with severe hearing loss.

But the best tasks we could come up with for Zoe were little things, like the human partner sending her downstairs in the morning, if I was up early, to let me know it was coffee time. Out hiking, Zoe took it upon herself to scout out the trail ahead, stopping at

trail forks to consult on which to take. There was also a lot of ball playing, and she invented tasks for herself, like patrolling the fence out front, tearing along it to keep the cars moving on, but jumping up on it to welcome pedestrians. Neighbors on both sides of us eventually got border collies themselves after daily exchanges with Zoe at the fence.

What really got me about Zoe was her eyes. She would come sit on the floor in front of me and stare at me—not the berserker look she would have used on the sheep, but neither that sappy look of adoration and submission we tend to associate with dogs. A look more like a question: "Hello? Are you there? Isn't it time?" It was as though she had something to tell me that required me to be able to converse in her way.

It got to me: "What, Zoe?" I would say. Sometimes she would actually lead me off, either to the door, or her food dish, or sometimes to some point where I could see no purpose at all. "*What?*" I would ask, and she would just stand there looking at me, tail in a slow swish, tongue out in slow thinking pant, waiting for me to get smart enough to understand.

Zoe made me think a lot about the "interspecies contract," whereby some of the wolves long ago decided to throw in with humans, to start collaborating with us rather than competing. Genetic analysis proves pretty conclusively that all dogs—even little Chihuahuas—are "wolves in dog clothing." There's a lot of speculation on when some of the wolves, coyotes, and foxes might have decided to switch rather than fight. Most guesses place it around the time, 10,000 to 30,000 years ago, when humans left off their hunter-gatherer lives and began to settle into agricultural and pastoral villages—farming where farming was possible, and herding the big herbivore herds where farming was marginal.

Both farming and herding should probably be viewed not just as "advances" in human culture, but as defensive measures brought about by the population increases that accompanied the mellowing of the climate with the retreat of the last glacial epoch. Gatherers started planting seeds in centralized watered places they could protect as pressure grew from other gatherers; hunters found themselves having to protect the herds they had always hunted from other human hunters as well as fending off the nonhuman predators.

The same kind of mellow-times population pressures grew among the nonhuman predators; a region can stand only so much new-pack creation among the wolves before they start killing each other at the territorial edges (like the humans do) or just starving, or both.

It was in that time of transition that the contract between wolves and humans was presumably born, at the edge of the firelight. Those who say "the leopard can't change its spots" have no answer for why the wolves were able to transcend their "instinct" to run down, harass, and kill the big herbivores, and perform the contradictory act of protecting them—even from their own kind who'd stayed beyond the firelight. My feeling (mostly from having known Zoe) is that it had to have been an act of reasoning, the kind of think-

ing that we humans are supposed to have a sole proprietorship on, however little we seem to employ it.

They did it for the meal ticket, of course, and the symbiotic relationship often descended into species exploitation, a kind of slavery with the dogs usually on the receiving end. Some people tyrannize their dogs, turn dogs into killers of humans or other dogs, usually probably some reflection of something still bestial in humans that indulgent cultures permit us to express.

A very engaging and really haunting novel about dogs and humans is *The Story of Edgar Sawtelle* by David Wroblewski, a story of three generations of dog breeders in upper Wisconsin who were trying to breed a strain of super-smart, empathetic dogs. The book included a correspondence between the grandfather and another dog breeder, who skeptically observed that the only way we're going to get better dogs than we have now is to become better humans. Having known Zoe, I can only agree.

**GEORGE SIBLEY** is the author of *Part of a Winter: A Memory More Like a Dream* and *Dragons in Paradise: On the Edge Between Civilization and Sanity.* A longtime journalism professor at Western State College, he lives in Gunnison.

**George Sibley practicing interspecies contact with Zoe near Crested Butte. Photo by Maryo Gard Ewell.**

**TOP** Misty at 12,000 feet among 12 million wildflowers along the Colorado Trail. Photo by human companion Gary Zee. **BOTTOM** Story told by human companion/photographer Farland Fish: I stopped at a Navajo jewelry stand on the Big Rez in Arizona and noticed this dog in a pack of feral dogs. The woman at the stand encouraged me to take him. As I drove off she called out, "Give him a good name!" His name is Sticky. He had never seen any expanse of water before and was instantly mesmerized. Here Sticky is sitting in the Colorado River outside Fruita at the Loma boat put-in.

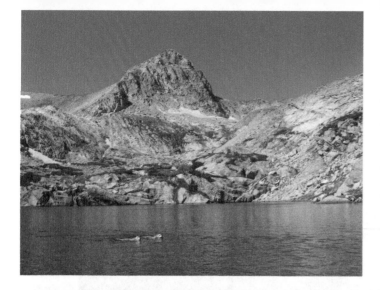

**TOP LEFT** Littermates Lucca and Mazzie swim in the cold water of Blue Lake in the Indian Peaks Wilderness as Mt. Toll sits above them. The only thing not seen here for these best golden retriever friends is the ever-present tug-of-war that awaits once they get on dry land. Photo by human companion Jay Kenis.

**TOP RIGHT** Wilson up Deer Creek Park, near Ken Caryl. Photo by human companion Kenny Schlagel. **BOTTOM** Kali, left, and Teewinot, romped through twenty-one inches of fresh powder on Independence Pass while their people, Cindy Klob and Janet Urquhart, skied up the road. Janet took the photo.

**TOP** Magnus Magnusen, a husky/Lab mix, catches air with human companion, Leadville resident Michael Bordogna, on Mt. Arkansas. Photo by Sterling Mudge. **BOTTOM LEFT** Border collies Zip (driving) and Cedar sitting in human companion Beverly Compton's 1976 Toyota LandKruiser on Missouri Heights, between Carbondale and Basalt. **BOTTOM RIGHT** Loki, a rez dog rescued from Kayenta, sings his way through a flat-water section of Westwater Canyon. Photo by human companion Brad Sablosky.

# true feelings expressed

▲ Winston, somewhere in southwest Colorado, near the Four Corners. Name of current human companions: Unknown. Photo by Maren Jaffee. ▶▲ Toby classes up the mountain wedding of his mom and dad, Megan and David November, by bragging to the crowd about what he can do that the rest of those in attendance cannot. If licking himself while sitting as his mom and dad got married was not enough, he laid down, got comfortable, and continued. Normally well behaved, Toby was adopted from the Summit County Animal Shelter by his mom and enjoyed many adventures in the Rocky Mountains before reveling in his retirement years in lovely Cleveland, Ohio. As handsome a dog as there's ever been, for the eight years he lived in Colorado, Toby loved skiing, running, and hiking with his human companions. Photo by Jay Zednik. ▶▶▲ Bear hates being the subject of a photograph. But he does like hiking in Gilpin County with family members Gayle Bush, who took this photo, and Jamie Colledge. Bear's other antics when confronted with a lens include turning his face away or vacating the scene entirely. ▶▼ Duke was a rulebreaker of all sorts, as evidenced by this legal transgression in Durango. Photo by human companion Kelly Bulkley.

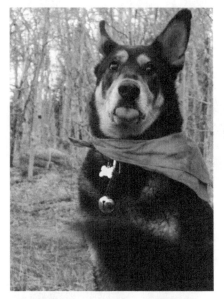

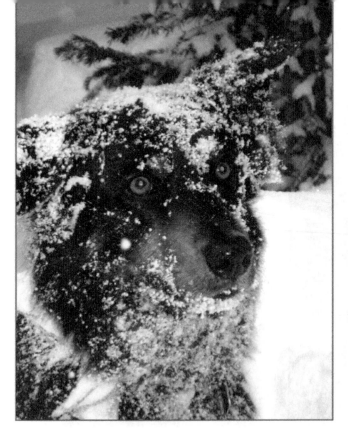

▲ Hopi runs like the wind, climbs rock like no other, and dives belly first, with complete abandon, into every droplet of water. Her two-legged dad (Jack Hughes) is a salmon fisherman in Alaska and mom (Eileen) is the general manager of KBUT, Crested Butte's community radio station. This photo was taken by Hopi's aunt, Michele Simpson, deep in the pow on a tour along the Slate River, breaking trail in snow way over her head. Somehow, Hopi knows this stuff is water too. ▲▶ Possum, a blue heeler, whose human companion is Tim Heenan, enjoys the results of a twelve-inch storm in mid-Feburary 2008 in Leadville. ▼ Kitchi snoozing in a blizzard on the back deck of human companions Sean Lynn and Laura Praderio Lynn, of Idledale. Laura took the photo.

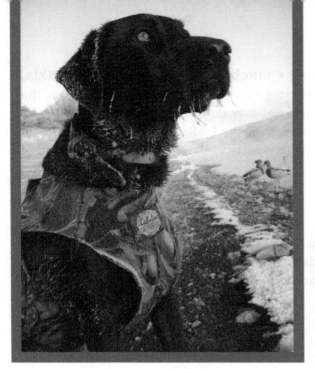

## best use of camo

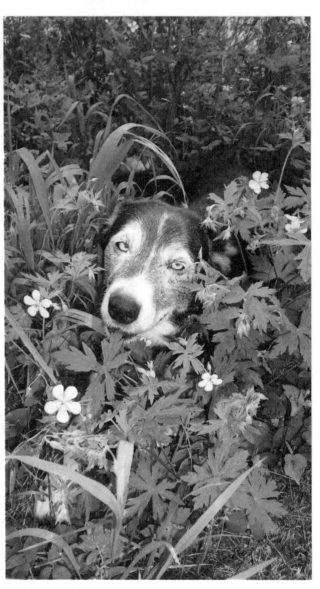

▲ Sage trying to will a duck to appear out of empty skies, near Parshall. Photo by Nate Anderson. ▶ Angel often wandered off during our hikes together but could usually be found taking a break in a patch of flowers nearby. Not sure if she enjoyed the natural perfume of columbines, or the shade provided by them, but she sure had a knack for finding the nearest flower patch and using it as a bed. Who wouldn't if they could? Angel lived with me in Villa Grove, in the northern San Luis Valley, before she was killed by a mountain lion while asleep under her favorite piñon tree just beyond my log cabin. Photo by human companion David Beaulieu.

**Eating Wolf** By Tricia M. Cook

**I have stopped at the top long enough to rip the skins from my skis,** taking breaths more slowly now than the ones I stopped counting on the way up. The even, heavy cadence of my breathing as I lay down a fresh up-track is addictive. The exhale louder, more pronounced than the inhale. The short, quiet space in between each breath. The solid and unexpectedly slow and deep pound, pound of my heart. Opium.

Shush, click.

Shush, click.

Shush, click.

From pull-off to top. Ski sliding against the micro topography of snow. Shush. Heel striking down, binding against binding. Click. And then the other ski, shush, and then the other heel, click. Shush, click, back and forth, one and then the other,

all

the

way

up.

From the top, I lock my heels, turn my toes to the tall trees below. If I am lucky, I will float. The snow is better here. Soon the trees will disappear and all that remains will be the narrow spaces in between. And the cold air I am breathing. My exhale louder, more pronounced than my inhale. The short, quiet space in between each breath. My heart now in my ears.

Some of my turns are snaked and some are kicked, as I work my way down through the maze of in-between. . . .

I pop out on the north side, on another mountain, laying fresh tracks with my Wolfdog. Snow makes him high and it is absolutely everywhere. The peaks go all the way up to Canada from here, and then they keep going on up from there. It is enough to make me dizzy and so we keep on going higher. The Wolfdog is grinning big, his pink tongue extended out long, like his long, long legs. He is running beyond fast, all four paws airborne at once. Flying.

My heart is pounding and it grows wings and flies right on out of my chest. There is no other way to put this: I am so goddamn, unbelievably happy. And the mountains are so goddamn, unbelievably beautiful. I holler a WAHOO! And I know, just know, that this is one of the best times of my life, and I do not ever want it to stop.

But it does stop, much later on. This time will roll into the next, and there will be other amazing times, but not one as beautiful as this one, when I am so unspeakably happy and my heart and my Wolfdog are both flying through the snow straight out ahead of me. Free.

I was right as rain about all of that.

I snake out one last turn onto an east slope, and a lot of time has passed. Skins are back on my skis and I carry my Wolfdog in an old and battered Nalgene water bottle tucked in my pack. We both drank water from that beat-up bottle, and it seemed like a good place to keep his ashes.

The new puppy keeps right up with me, following close behind in the up-track, without stepping on the backs of my skis. He is a similar mix as my Wolfdog was, but I don't see my Wolfdog when I look at him, and for this I am grateful. We top out at the frozen lake and find the perfect spot for a handful of my best friend's ashes. Here, there are three ponderosa pines, a view of the lake and craggy ridgeline.

**After big adventures in the alpine, Zen-puppy Arrow rests on a soft bed of emerging spring grasses and in the cool shade of tall pines. Photo by Tricia M. Cook**

I pull off my pack and pull out the Nalgene. My heart is breaking, just as it does every day now. I unscrew the lid and pour some of my Wolfdog's ashes into my naked, outstretched hand. The sun is low, the air still. Gently I shake the ashes from my hand and they land gracefully near the three ponderosas. The puppy, I call him Arrow, bounds on over, taking a big, exuberant bite of snow, and of Wolfie's ashes.

I am kneeling in the snow, feeling a little stunned. Through my tears, I smile at Arrow and touch my tongue to the palm of my hand where some of Wolfie's ashes remain.

It is time to ski down, before we lose any more daylight. My long-legged puppy stays just ahead of me and off to the side, keeping his amber eyes on my turns, brilliantly steering clear of my skis, yipping at me to go faster, faster, faster PLEASE! He is a good dog. He has a tough act to follow.

It will not stop hurting, but I will become accustomed to the hurt, the sharp intake of breath, the breath held until I absolutely have to let it go and take another one. Down at the bottom, I squeeze my hands into fists and press them against my chest and then against my eyes. I do not want this good pain to go away. Ever. I will hold on to it as if my life depends on it. I think my life does depend on it. And if I am lucky, I will float. . . .

TRICIA M. COOK was a senior correspondent for the *Mountain Gazette*. A longtime resident of Washington's North Cascades, she now lives in Colorado's San Juan Mountains with her two big dogs, Arrow—now full grown—and Maiya.

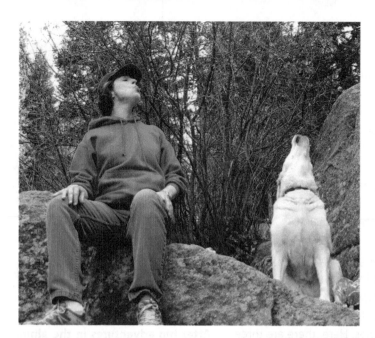

**TOP** Hana and her human companion, Kate Gillette, practice howling like wolves at Maxwell Falls near Evergreen. Because Hana and her family had moved to Colorado from Belgium only six months earlier, they didn't know that the nearest wolf pack was in Wyoming. Photo: Jim Gillette. **BOTTOM LEFT** Yoshi in her backyard in Fort Collins. Yoshi got her name from the Flaming Lips song "Yoshimi Battles the Pink Robots." Human compan-

ions: Patricia and Derrick Taff. Patricia took the photo. **BOTTOM RIGHT** Part Labrador retriever (and possibly part mountain goat), Russell is on his way to the top of Buffalo Mountain near Silverthorne. Russell's canine parents were very hard workers— a DEA drug-sniffing dad and a field-trial-champion mom. He prefers the lifestyle of his adoptive human family (Lisa, Eric, and Natalie Hunter), which includes lots of outdoor playtime in Sum-

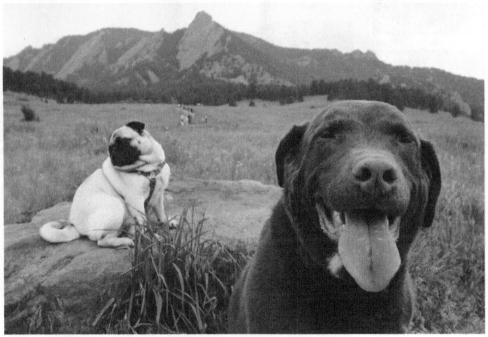

mit County. **TOP LEFT** His Divine Grace, the fourteenth Doggie-Lama, Dr. Ben Funbeast representing all life on earth at the pan-galactic council of all beings. Photo taken on The Mountain by his human companion, Van Clothier. **TOP RIGHT** Scout riding home in the Avalanche after helping pick out a tree from Rampart Range with her owners, Steve and Donna Scheer. Sonny Scheer took the photo at a friend's house in Woodland Park.

**BOTTOM** Windsor and Monkey resting in front of the Flatirons in Boulder. Windsor is thirteen. His hindquarters are starting to fail him. His best summer activity this year is swimming with his ball in a small pocket park in Crested Butte. Photo by human companion Caroline McLean.

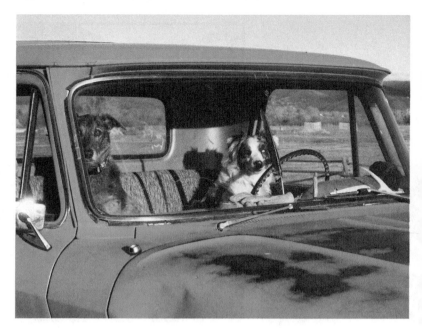

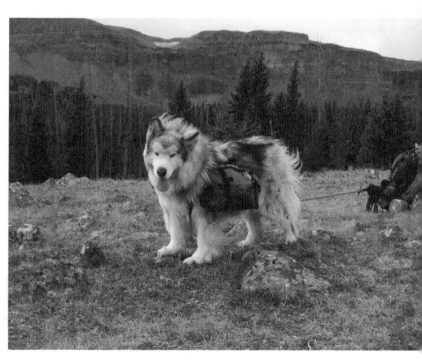

**TOP LEFT** Kyra (RIP), whose people were Stephen and Jeanne Wenger of Glade Park, learned the word "look" in just one evening of driving around looking for deer, though she may have thought it meant "deer" for a while. Photo by Stephen Wenger.
**TOP RIGHT** People in the intermountain West like to talk about "sense of place," but these dogs live it. Human companion Jona-
than Houck got Miranda and Ruby from multigenerational ranch families east of Gunnison. Although they live in town, when they are out working on the ranch, they become old souls, wise and sage-like. This photo was taken after a day of irrigation work and captures that intensity. They look as if they are about to speak.
**BOTTOM LEFT** Keetna has explored Colorado's backcountry

from Steamboat Springs to the San Juans with her human companion, Jeff Holland. Here she is flying high in the Tarryall Mountains/Lost Creek Wilderness. **BOTTOM RIGHT, OPPOSITE** Nakoah, a purebred malamute, was five when this photo was taken during a late-season fly-fishing trip along the Derby Creek Trail in the Flat Tops Wilderness. Nakoah is carrying forty pounds in his pack, twenty pounds on each side. Photo by human companion George Petrick. **ABOVE** Diego was a rescue dog found by her human companion, Joanna Gordon, in Gallup, New Mexico, with a slit throat. Despite his rough start, he has been kickin' ass across the West for nine years. Photo by Diego's stepdad, Clint Casey.

# The Naming of Dogs

**One of my favorite aspects** of sifting through the tsunami of photo submissions I received every year for *Mountain Gazette's* Mountain Dog Issue was eyeballing the various dog names, which, needless to say, covered a wide nomenclatural spectrum.

There were always plenty of what I would call "normal" dog names—Sage, Spade, Blue, Ella, Nico, and Seamus.

Always lots of names that end in a phonetic long "e"—Ozzy, Sophie, Kiki, Mali, Bertie, Mazzie.

And there are usually lots of names that are mountain-specific—Tundra, Talus, Chinook, Summit.

And non-dog animal names—Bear, Hawk, Lobo, Wolf, Fox.

And names associated with specific mountains and mountain ranges—Sawatch, Elbert, Denali, Shavano.

Often, there are town names—Frisco, Dillon, Juneau.

There are names from literature and popular culture—Gandalf, Frodo, Yoda, Stella, Homer, Zool.

The most captivating (some would say strange) dog names I have ever come across, however, did not make their way into my life by way of our Mountain Dog Issue.

There's one dog that visits our local dog park on occasion named, of all unappealing things, "Pot Roast." Pot Roast is an overly affable bulldog whose main attribute seems to be an ability to slobber so profusely that you have to wonder where all that liquid comes from. I have seen tropical waterfalls that pass less liquid than does Pot Roast. Pot Roast jumped up on me one time, and, in the point-five seconds it took me to move away, his slobber had saturated the front side of one pants leg so thoroughly that it soaked clear through—and here I'm talking about from upper thigh to ankle—to my skin and, even in the bright sun, that leg did not dry out for two solid hours, most of which I spent on the deck of a local watering hole having people ask me if I had just urinated my pants. The whole time, I could not let go of the feeling that what had drenched my pants leg was not dog slobber, which is bad enough, but, rather, given the dog's name, greasy pot roast gravy. I finally had to leave the bar to go home and change pants and bathe my sticky leg.

I was once walking back to my car one hot summer day after having visited the local all-natural grocery emporium, and, from the inside of one of those kinds of cars that are literally held together by predicable, though ambiguous, hyper-liberal bumper stickers proclaiming that Peace is the Way and asking What Would Gandhi Do?, I heard a wild vocal ruckus. There was an aging hippie lady inside that car yelling at the top of her lungs in a way highly unbecoming of an aging hippie lady whose car is adorned with bumper stickers about Gandhi. What she was actually yelling made me ponder hiding behind a light pole, for I did not know the potential ramifications of her tirade. She was yelling, "BAD KARMA!!! BAD BAD BAD KARMA!!!"

Now, in a place as populated with wizards, witches, and god-knows-what as is the Mountain Time Zone, you can understand my immediate concern. I at first thought she was wishing bad karma upon me personally as I passed. I mean, in my grocery bags were indeed some items that, I guess, were one inclined to look at them thus, could be considered karmically less than pure. Even though it was grass-fed, free-range, and hormone free, yes, there was some breakfast sausage. And, well, I did have some pretzels, but, hey, they were completely free of GMO ingredients! I swear!

Then, I thought that maybe the lady was doing nothing more than recognizing that some bad karma was right then visiting her for reasons I could not possibly—and had no desire to—fathom. Maybe she had recently purchased some non-free-range sausage. Maybe she had just eaten a whole handful of pork rinds purchased at a convenience store. Maybe her loud vocalizations were nothing more than paying some sort of penance-via-recognition-of-sins.

When I finally mustered the courage to continue walking on by, I noticed that, cowering in the backseat of the car was a guilty-looking dog that had, more than likely, just chewed up a Birkenstock or something. Turns out, the dog was named Karma. Now, who would name their dog such a thing, I don't know. But there it was. And, in this case, the karma was indeed bad.

Back when the *Mountain Gazette*'s office was still in Frisco, our then-sales manager hooked up with a lady who brought to the relationship a dog named Groovy. Groovy was a big Weimaraner whose eyes did not always point in the same direction. He was also an escape artist nonpareil. One day, my buddy Mark Fox was asked to watch Groovy while the sales manager left the office to run errands. Mark's focus must have wandered, and, next thing he knew, Groovy was gone. Mark dashed out onto Main Street, where, even in a part of the country inclined to cut people their eccentricity-based slack, I'm sure he drew perplexed attention as he ran down the sidewalk shouting at the top of his lungs, "Groovy! Groovy!"

There are lessons to be learned from those anecdotes. One of the biggest thrills, and biggest pressure-filled challenges, of entering into a new relationship with a dog is coming up with a name. My last two dogs, Cali and Casey, came already named, though Casey had only been named the day before we picked her up from the Luvin' Labs dog-rescue group in Albuquerque. We could have changed her name at that point with no psychological ramifications. But Casey was as good as anything I would have come up with (given her demeanor on the five-hour drive home, I would have gone with "Fidget"), so we just stuck with Casey.

Dog experts have observations about dog names. Doggie 101 states that you should name your dog something short, no more than one or two syllables, so there is no confusion on the dog's part when the human companion is trying to gain their canine charge's attention when he or she is, say, rolling in something foul. Also, a short name resonates better when you're yelling it at the top of your lungs because D'Artagnan has run off into the woods after a rabbit.

Dog experts also stress that your dog's name ought to be something socially acceptable, something a significant other that you perhaps have not even yet met will not be embarrassed to hear enunciated at high volume in front of friends and family. Though this is a bit off target, species-wise, I once had a friend who, for reasons that now thankfully escape me, named his cat "Crotch." While "Crotch" might not cause raised eyebrows when applied to a cat in the comfort of one's own hovel, it would translate less than optimally when you're out in the woods with your thusly-named dog and you pass by the local senior citizens' hiking club.

Dog experts further point out that, if you have more than one dog, you ought to give them names that sound nothing alike. A couple of my closest friends once named their littermate corgis "Tillie" and "Lillie." This caused problems when run through the circuitry of corgi thought processes, which are already obdurate enough for most people's taste. After several months of making no headway in their efforts to corral their wayward corgis, my friends changed the dogs' names to, appropriately enough, "Thelma" and "Louise." Things improved on the dog-herding front, but only marginally, since we are, after all, talking about corgis.

This leads to one final point about dog naming: Experts argue that, once your dog has learned a name, whether given by you or perhaps previous human companions or the nice people at the animal shelter, you ought to keep that name, in order to minimize confusion. If you do opt to change the dog's name, say, because "Pot Roast," "Groovy," or even "Crotch" is not to your liking, try to change it to something similar. One of my friends adopted a pup already named

"Jilly," a name he did not like. He changed it to "Lilly," with no noticeable adverse consequences.

I will add this: Give your dog a name that reflects his or her spirit, one that imparts an appropriate level of dignity that all dogs deserve.

No matter what name you choose, it will remain with both of you through thick and thin for, hopefully, many years to come.

—M. John Fayhee

**Though he is deceivingly at ease in this shot, Groovy was an escape artist with few peers. He should have been named Houdini. Photo by Jim Marsh.**

▲ Lurch, who was born in Sugar City, enjoys the snow in Ketchum, Idaho. Human companion: Jay Freis. ▶ Maya keeps a sharp lookout for coyotes while crossing a frozen lake at sunset just south of Denver. After being raised from a puppy in Summit County, this became a favorite cross-country skiing spot for Maya and her human companions, Sarah and David Watson, while they spent a few years on the Front Range. Maya is now eleven years old and loving life in Eagle. Photo by David Watson.

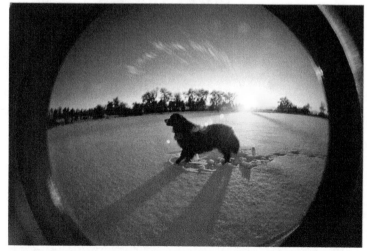

# most creative

▼ At ten weeks old, (Lor)Etta was adopted from the Summit County Animal Shelter by Jeff and Natalie Shelker. Etta climbed her first Fourteener (Handies) at fourteen weeks old and has been on the go since. This photo captured her in a rare moment of pause, in Utah's Little Wild Horse Canyon, with her face expressing the joy she feels for any outdoor activity! Jeff took the photo. ▲ Layla (foreground, border collie/husky) and Artie (background, miniature Australian shepherd) deliver a Public Service Announcement during DJ New Drew's weekly slot at Radio Free Minturn. Human companions: Andy Armstrong (Layla) and Andrew Trumbo (Artie). Photo by John Scheid.

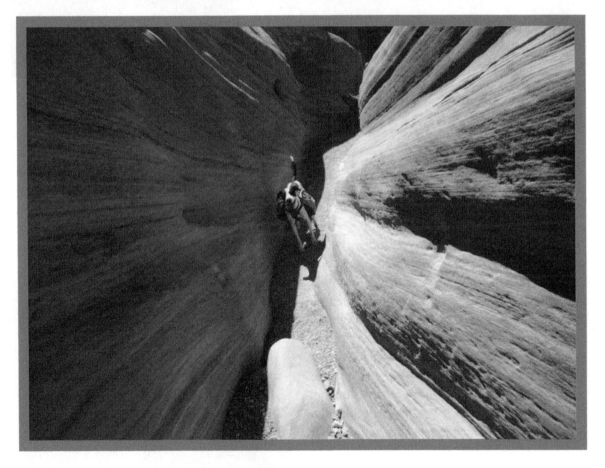

# best compadres

▲ Nancy Bell and Jack in the Cirque of the Towers, Wind River Range, Wyoming, at sunrise while breaking down camp on a four-day backpacking trip. The photographer is Estes Park resident Kurt Johnson. ▼ Littermates Frisco and Dillon Alexander, of Monument but frequent visitors to Summit County and thus their names, at the Frisco Nordic Center, fired up for a snowshoe with owner and photographer Jay Alexander. ▶▲ Cody and Sage Anderson agreeing to split "King of the Mountain" reign on a camping trip near Fraser. Sage is a six-year-old Lab with just enough drive, spirit, and sense of adventure to make her the perfect addition to any family outing. Photo by Nate Anderson. ▶▶▲ Malibu leading the new puppy, Tiki, into the waters of Dillon Reservoir for the first time. Photo by human companion Sue Feldmann of Frisco. ▶▼ Buddy with human companion Brett R. Davis on the summit of Battleship (Peak 12,442, south of Red Mountain Pass). Taken right before man and dog dropped in for 2,400 feet of Colorado powder. Photo by Kylin Lee.

# The Legend of Riley

By Bob Winsett

**Riley in front of ancient cabin remains up Mayflower Gulch. After Riley passed, Summit County photographer Bob Winsett, who took this photo, was inspired to write a memorial poem to Riley's human companion, Jamie Bailey, of Montezuma.**

### The Legend of Riley

The wind sweeps over the high alpine ridge
Above the Bullion Mine.
It carries with it summer's scent
As it works up the steep incline.

It reaches a place where some boards are crossed,
Where the view is truly grand.

It's a place where memories come flooding back.
It's the place where I now stand.

It was here that Riley was last set free
To play where the mountains meet the sky.
It is here that I know his soul still runs.
I can feel him if I try.

The mountain goats have heard of Riles.
The marmots speak his name.
The hawks swoop down to chase his tail
In a never-ending game.

Santa Fe, Bullion and Ida Belle
Are among the sights that he has seen.
Going ridge to ridge with Jamie by his side
Was what kept him strong and lean.

Together they explored old cabins
That were abandoned long ago.
Over the years they shared so many things
In the grass and in the snow.

They shared secrets that come from the heart.
They shared sunrise and sunsets too.
They shared time up high and time on the couch
When there was nothing else to do.

His body is gone but his soul lives on
In these mountains where he first ran.
If you're quiet now and you close your eyes,
You can feel him. I know you can.

▶ Hopi from Kayenta makes a sharp turn in the snow, leaving his tongue behind in the process. Photographed by human companion Mike Freeman and a 1974 Vivitar Pentax in subzero temps on the Animas River in Durango. ▼ Skylar Blue at the Delaney Dog Park (aka "the nature park") in Carbondale. The photo was taken when Skylar was four years old. She is ten now. According to her human companion, Julie Ivansco, Skylar is the sweetest, most loyal, most neurotic dog ever. ▼▶ In September 2007, Gary Lorenz disappeared from his home in Cotopaxi. He had Alzheimer's disease. His body was found three weeks later. His dogs, Pippin and Merry, stayed with their master, guarding his body. They lost about nine pounds each but otherwise they were pronounced healthy. The three-year-old dogs, brother and sister, were returned home shortly thereafter. Lorenz's widow told the *Salida Mountain Mail* that finding the dogs was "bittersweet" because she and her daughter were glad the dogs were found, but were sad to lose Gary. Here are Merry and Pippin during better times. Photo by Tim Cooper. ▶▲ Ely catches some big air in Fort Collins. Photo by human companion Mark Machacek.

▶▼ Bwana diving into Williams Lake, to the amusement of his human companions, Lari Goode, who took the photo, and Mark Fischer. ▶▶▼ This is Lola, a dog that is savvy and well versed in the art of mountain adventures. She steers clear during descents, doesn't walk on the tails of your skis (a few knocks to the chin took care of that), and leaves the mountain denizens alone (well . . . most of the time). This photo was taken of human companion Chris Johnsen of Frisco by Daymon Pascual during a backcountry ski day that involved hiking "Conoco Chute" (near Copper Mountain), skiing the east face of Peak 4, then back.

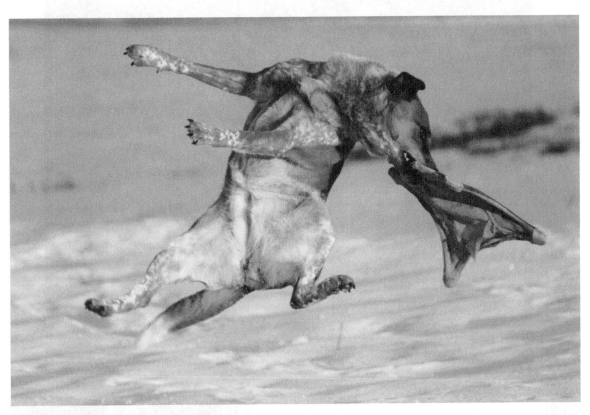

# ACTION!

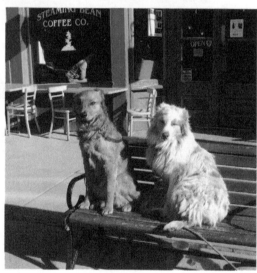

**TOP** Hendrix, who was rescued from an aspiring meth house in Greeley, in the Rawah Wilderness (somewhere east of Grassy Pass). Hendrix and human companion Kevin Studley had traversed from South Rawah to North Rawah Peak, saw several moose (meese?), and ran into a family from Texas on their way back to camp who asked where Hendrix and Studley were headed and, when Studley told them about their big day, the father's reply was, "Well, shit!" **BOTTOM LEFT** Macy May was rescued from suburbia in Scottsdale, Arizona, and relocated to beautiful southwest Colorado by Sandy Canright. Here she smiles in the lupines on Dallas Trail above Box Factory Park. **BOTTOM RIGHT** Outside the Steaming Bean in Telluride, these dogs were hanging out obediently waiting for their owners to return. Just posing and being cute. Not even looking for hand-

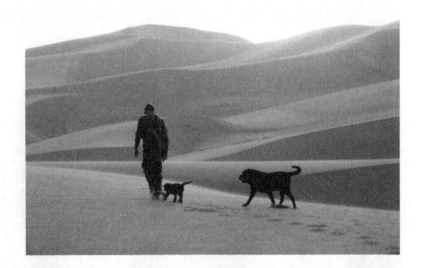

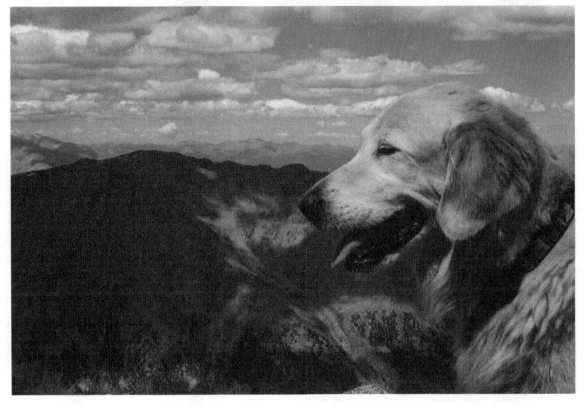

outs. Just being cute and loving life in that southwest slice of heaven. Owners and dog names are unknown. Photo by Frisco resident Mike Petrello. **TOP** Paul McClelland leads his black Labs, Chuck and Big Jim, across the Great Sand Dunes National Park. Chuck was about twelve weeks at the time. Chuck has since competed in FIBArk's Crazy River Dog Contest. Big Jim is now building sand castles in the sky. Photo by the other human companion, Kate McClelland. The McClellands live in Salida. **BOTTOM** Clover on the summit of Mt. Columbia. She was eleven at the time. She lived to be seventeen and summited twenty Fourteeners in her lifetime. She was also the faithful research assistant for all three editions of the book *Canine Colorado: Where to Go and What to Do with Your Dog*, penned by Clover's human companion, Cindy Hirschfeld, of Basalt.

**TOP** Toby poses handsomely on Bald Mountain near Brecken-ridge on an afternoon ski as a storm clears. Skiers hooting while enjoying some backcountry powder nearby caught Toby's attention as the sun broke through the late-afternoon clouds. Photo by human companion David November. **BOTTOM LEFT** Daisy, Dudley, and Chester sit on the bank of Straight Creek after a refreshing dip after their run. All are rescue/shelter dogs who love their life in Summit County with human companions Suzie and Dave Ver Schure. **BOTTOM RIGHT** Jackson, taking a break while thru-hiking the Colorado Trail in the Tenmile Range between Breckenridge and Copper Mountain. Photo taken by Jackson's human companion, Jeffrey Bright.

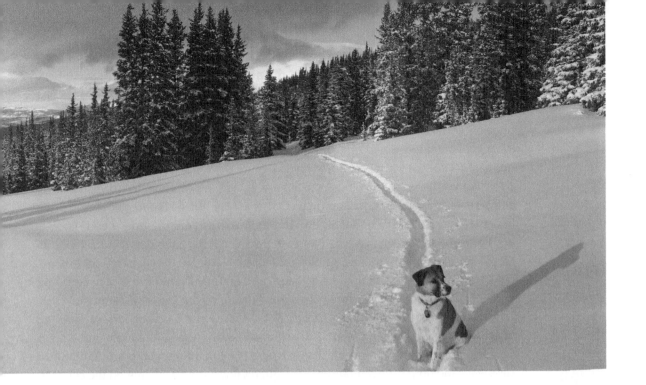

**BOTTOM LEFT** Milo and Heather on Shrine Ridge, near Vail Pass, with Mount of the Holy Cross in the background. Heather is Milo's aunt and Milo takes care of her by packing all their water on the trail. Human companions: Betty Dinneen and Rich Boscardin. Photographer: Betty Dinneen. **BOTTOM RIGHT** Denver, a black Lab/Belgian mix who was rescued from a shelter in Colorado, was only three months old when photographed with human companion Brad Masseur at the top of the Manitou Incline near Colorado Springs. Denver is now is now a successful service dog, whose other human companion is Leanne Henderson.

**W**hen you see a bassett hound galumphing through grass, his belly dragging the higher-reaching blades and his ears tipped in bracken, your first thought probably isn't, "There's the mountain dog for me." And if you saw one of these ungainly critters cavorting high on a Fourteener, you might even feel pity—or outrage. What kind of master would bring such a slow-tempered waddler up onto these strenuous peaks? Only the vilest bastard, surely. . . .

But you haven't met Wilbur. Wilbur is eleven now, his ears hanging lower than ever and his muzzle as white as the Snowmass Glacier in May, but in his prime he racked up an impressive ticklist, mostly under his own power. True, his "mommy"—my friend Haven—and I often had to give him a boost (or even pack-carry) here and there. But Wilbur (aka Wee-beez, aka Wing-dingz) became our constant companion at the cliffs and in the mountains. He insisted—by upsetting the garbage can, tearing into any food within reach, and pooping on the floor—that we not house-bind him during our long days climbing.

And so Wilbur climbed the Second Flatiron, the Kelso Ridge of Torreys Peak, the Sawtooth Ridge connecting Mounts Bierstadt and Evans, Green Mountain (more times than I can count), a 5.5 approach slab in Utah's Maple Canyon, and third- and fourth-class walls and ridges too numerous to list. But his finest moment came on the connecting ridge between Shavano and Tabeguache, two silent peaks on the southern end of the Sawatch Range.

If you've done Mount Shavano (or even if you haven't), you'll recognize it as the alluring peak south of Buena Vista with the eponymous angel of a snowfield, arms stretched to the heavens in a steep Y of white that lends personality to the otherwise anonymous southeastern cirque. The good folks at the Colorado Fourteeners Initiative make the valid point on their website (14ers.org) that climbers should stick to the Blank Gulch Trailhead approach instead of straying into the (now closed) Jennings Creek basin, long overused and with cliffy deathtraps luring the lost, tired, or benighted summiteer. All Angel suitors begin at Blank Gulch, which is where Haven, Wilbur, and I geared up on an achingly clear June morning.

As with many a Colorado peak, early on the hike winds through trees, along silver rills, and up into the krumholtz before piercing tree line, getting the legs and blood up just enough for the quad-pounding summit push. Wilbur loves the trees and the deer and elk scents there—perhaps too much—and so stayed leashed till we'd shuffled into the toe of the Angel. Then, untied, he began his shtick: running up and down (and up and down) the thirty-degree snow; butt-glissading with his ears flapping as he slid with unsullied joy against our shins and knees; hastening after pikas and howling at us with pre-summit angst; and sometimes post-holing with his little bassett legs, only to pop anew out of each snowy sump, his snout packed with graying slush. For three times the work, he had six times the fun—maybe more. We made the summit in good time and

By Matt Samet

# Wilbur Ridge





gave Wilbur some water, passing bits of energy bar his way, too.

Haven felt unwell, so she rested atop Shavano while I picked my way across the mile of gentle ridge to Tabeguache. (A restive climber, I always need more, more, more.) Wilbur stayed to keep an eye on her. I set off, talus-bopping quickly, skittering along snowpatches under benign balls of cloud and a sharp-blue early summer sky. Down to the saddle and then up again, moving slowly in the thinning air and finally coming onto the finishing ridge, a sloping sidewalk that broadened onto the summit shoulder.

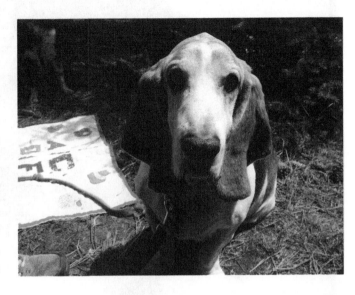

**Wilbur defied his basset hound lineage by cavorting with aplomb through the Colorado Rockies. Photo by human companion Haven Iverson.**

*Woof! Woof! Woof!* Basso barking in the distance—Wilbur? Was Haven OK? Just shy of the summit, I turned around in time to see a small dot scampering across the snowy saddle, 500 vertical feet below. Hmm, Wilbur—irrepressible Wilbur. I could catch up with him during my descent, and then we'd hurry back. I started hiking again. Five minutes later, just as I steadied for a summit self-portrait, Wilbur bounded over the horizon, coughing, wheezing, hacking—his jowls frothy with exertion—but still running nonetheless . . . sprinting for the apex. His soft bassett ears flapped with each paw-fall.

"Wilbur!" I shouted. "Damnit, Wilbur . . . what is this? Is Haven OK?" He plopped butt to stone, panting, fixing his gaze on me. I poured him water, holding my hand against his heaving flanks as the tension in his little form began to settle. We rested that way, a man and a dog and mountains—only mountains—and then charged back toward Shavano. Soon, we came upon a napping Haven, who woke up long enough to tell me that Wilbur had taken off a full forty minutes after I had—i.e., he'd traversed the whole ridge in about a quarter of the time. Not because Haven needed help, and not because I needed the company—no, I don't think so. Only Wilbur knows why he ran that ridge, though I suspect his answer is not so different from my own.

**MATT SAMET is the author of *Death Grip: A Climber's Escape from Benzo Madness* and *Climbing Dictionary: Mountaineering Slang, Terms, Neologisms* and *Lingo: An Illustrated Reference to More Than 650 Words*. Samet was once the editor of *Climbing* magazine. He lives in Boulder.**

# best expression

▲ Josie was rescued as a pup from the streets of Leadville by human companions Bill and Linda Marvin, who live in Silverthorne. When not out and about, she is the reigning OD (Office Dog) at Hodges/Marvin Architects in Summit County. The photo was taken by Linda at Breckenridge's Carter Park Dog Park. ▶▲ Story told by human companion/photographer Farland Fish: Sticky on left and Gnomie on the right. Fierce rez dog play. This photo was taken up above Maroon Lake. Okay funny story: My sister was visiting from the East Coast. I took her up the Maroon Bells Road and, it being mid-November, I thought I could get away with the dogs being unleashed when, who should be coming down the trail but about twenty park rangers lead by the local ranger. I went to get leashes and, passing the local ranger, I told her that my dogs were from the Navajo Reservation and therefore exempt from leash laws in national parks. (This I just made up!) She told me that this was a group of the head ranger from every park in the nation and they wanted her to give me a ticket/fine. As I walked back through the group of head rangers with the dogs now leashed, they asked her if she had given me a citation. She said no and asked me to tell them why. So I stood there with my executive sister cringing at my side and repeated my story. The local ranger was grinning and the others are probably still looking through their rules books for that exemption. If my dogs had been Labradoodles, I'd have never gotten away with it. ▶▼ Moose was rescued from the shelter in Leadville by human companion Sean Maiorani. This picture was taken on the east side of town in the Mosquito Range while Moose was chewing on a tree stump.

best acrobatic skill set

▲ Hannah being lowered down the Dylan Wall in the San Rafael Swell after a day of rock climbing with human companion April Temple, who does not remember the name of the black dog that is spectating the procedure. Hannah passed away in 2009 at age fourteen. ▶▲ Kasie Rue and Skade take the plunge outside Crested Butte. David Baca is Skade's human companion, while Rebecca McCullom was Kasie Rue's human companion. Rebecca took the photo. ▶▶ Western Slope native Gnomie psyched to get going on a desert adventure outside Moab after spring break. Photo by human companion Farland Fish. ▶▼ Poet, a nine-year-old black Lab, leaps into Vallecito Lake. According to his human companion, David Halterman, of Durango, Poet is "a bad-ass lil mama jama, and he drinks Guinness to boot."

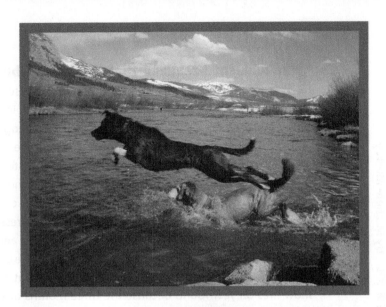

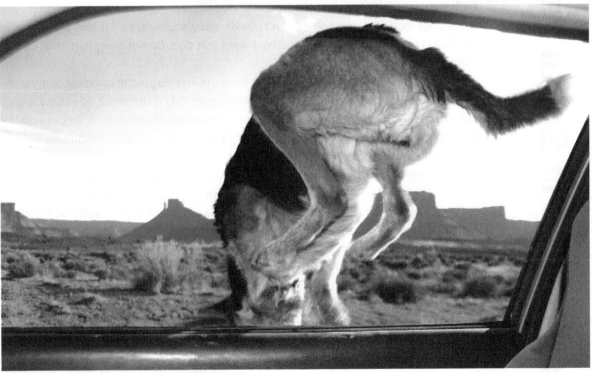

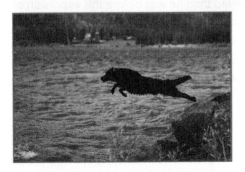

By Michele Murray

# Stink Bombs in South Park

**T**he moment I realized that the moving bush was a big, fuzzy, stray dog, I felt the Finger of Fate jab my chest. The dog seemed to be blowing down Main Street in Fairplay (the capital city of South Park) by the icy winter gale from Hoosier Pass. I answered the Finger of Fate: "No. I do not want this dog." The wind didn't listen. It continued to push the furry behemoth down the street like a tumbleweed on trotting paws.

Stray dogs in mountain towns can be problematic with undesirable aspects, such as being wolf-hybrids, child-biters, hole-diggers, couch-wetters, cat-killers, or by harboring medical issues like rotten teeth, diarrhea, mites, scabies, rabies, mange, etc. I have learned that taking in a stray of that size can be very stressful.

Later that morning, my office door swung open and Mary Ann said, "Waaaaaah—come see this beautiful dog I found—he's so sweet! We can't keep him, though."

Mountain people do not want more dogs, but for some reason—like keeping snow tires on year-round because the three months of summer is not long enough to bother swapping tires—mountain people who do not want more dogs end up with more dogs (and cats and horses, ducks, owls, baby squirrels, etc.). I told Mary Ann as clearly as I could express myself: "I do not want that dog. Do not bring him here. Do not show him to me."

After work, I was driving home with the large fuzz-bag in the backseat of my crew-cab pickup truck. (I do not know how that happened.) My route home was about eighty miles each way from Fairplay to Victor. I put the dog inside the truck with me because the temperatures in South Park along Highway 24 are arctic cold. Plus, I didn't know if he would jump out of the bed of the truck.

"Dusty" (I got his name from the veterinarian) had a history. When he was born, he was a "surrender" (an animal handed over to the pound) because he was a wolf-malamute hybrid. Shortly after he was adopted (and "chipped" for electronic tracking), he contracted distemper, which he survived, but, as a result of that disease, he was susceptible to epileptic episodes—full grand mal seizures. He weighed 127 pounds and had to take antiseizure medicine twice a day. Stress could trigger a seizure, so if he felt hungry, you needed to feed him right away (a lot).

As I drove, I watched him in the rear-view mirror wondering what kind of temperament he had. Mary Ann was right: He was a very sweet dog. I was admiring his countenance, when the atmospheric composition of the inside of the truck turned rancid. I looked at Dusty with disbelief at the volume of gaseous poison he had just expelled into our chamber. He did not seem to be more relieved than he was before this expulsion of noxious fume. My eyes were watering as he continued to emit stink bombs with benign indifference. I rolled the windows down even though the wind was freezing.

I could not believe the pungency of this animal's digestive emissions. He must have corroded intestines. Managing the drive was verging on unbearable to the point I

thought of pulling over and ejecting him. I wondered if that heinous crime was exactly what happened earlier this morning—had some other family been unable to take one more fetid fart and simply cut the pungent gasbag loose on Main Street?

These conditions were very distracting. I was concentrating on maintaining consciousness when I heard an odd, muffled sound. I looked over my shoulder to see that he had fallen into the space between the backseat and the front seat with his legs straight up. His width totally filled the space. He was good-and-stuck. A few more unbelievable farts escaped his inverted carcass, and then he relaxed and stayed that way. I knew he wasn't dead because I could feel him breathing against my back.

**Dusty relaxes in the comfort of a snowstorm near South Park. Photo by Michele Murray.**

Dusty proved himself to be an unusual and charismatic dog in many ways. We fell in love with him (and fed him less combustible food). He lived with us for the rest of his life. Thank you, Mary Ann.

MICHELE MURRAY lives in South Park with her huzbun and dogs. She writes humorous essays for outdoors writing venues including Coloradofishing.net.

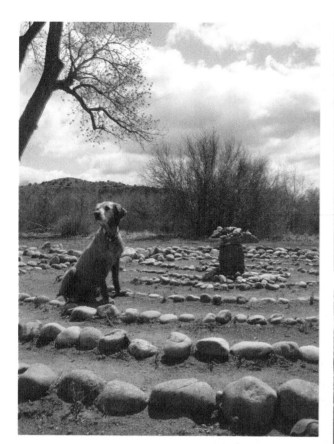

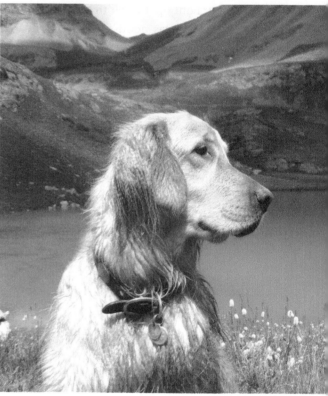

TOP LEFT Kasie Rue on a spring trip with her human companion, Rebecca McCullom, to Ojo Caliente Hot Springs, New Mexico. TOP RIGHT Jake and Wally on the Walrod Trail outside Crested Butte. Photo by human companion Heather Still. BOTTOM RIGHT Kelsey Fulton at Ice Lakes. While she failed at search-and-rescue, according to human companion Kirsten Fulton DVM, she succeeds at looking fabulous daily! TOP, OPPOSITE Diane Burrell with her dog, Woody, in the Sangre de Cristo Mountains. Photo by Bill Burrell. BOTTOM, OPPOSITE Daisy Dozer is a ten-year-old chocolate Lab/Weimaraner mix who suddenly turns into a puppy when playing in the snow! Because of her short hair, she needs her fleece jacket to keep from shivering. Photo taken by human companion Don Kolinski at the Bar-K Ranch (also known as the Bark Ranch) above Jamestown.

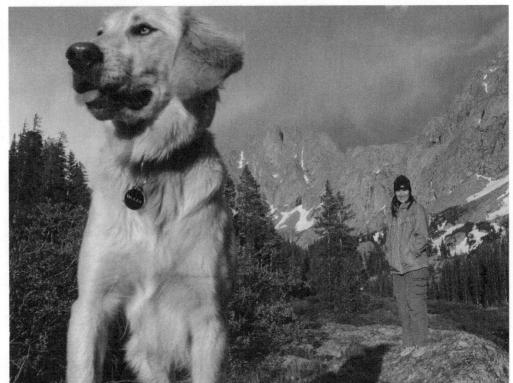

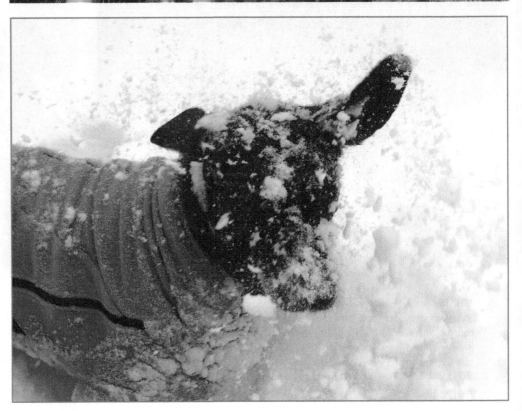

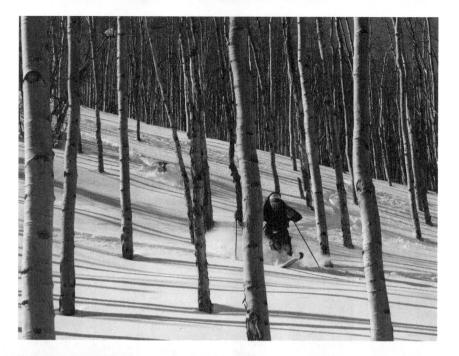

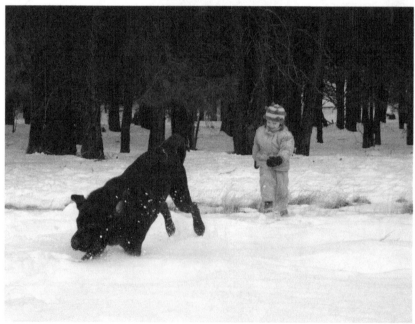

**TOP** The late Tally, who started out as human companion Brian Shaeffer's stepmom's dog. Tally chose Shaeffer after he finished college. She was his hunting dog in the fall and his skiing partner in the winter. Shaeffer provided the arm that threw her ball the rest of the year. The photo was taken in Lake Creek. **BOTTOM LEFT** Porter the chocolate Lab and his buddy Kaya Van Hoesen take a minute to play in the new snow after having posed for their annual Christmas card photograph. Photo by Todd Van Hoesen. **BOTTOM RIGHT** Milt, more formally known as Miltessa von Phwah, lived twelve of her fourteen years in Crested Butte as one of the premier Grand Dame Mountain Dogs of CB. Her favorite haunts were Irwin, Oh Be Joyful Valley, Paradise Divide and, for happy hour after a long day's hike, the Eldo: A Sunny Place for Shady People (and apparently good

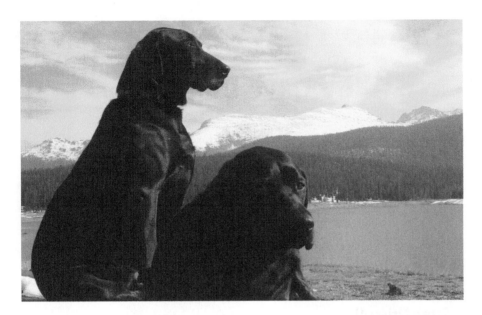

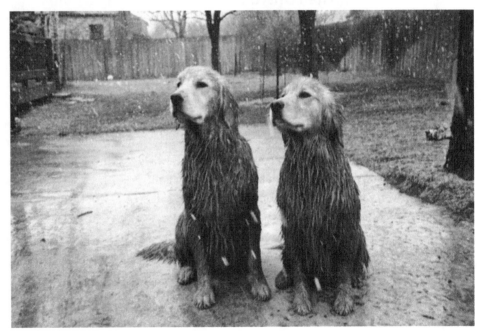

dogs). She hung her toes off the edge of Mounts Hood, Shasta, and Saint Helens while living in Oregon, and looked beyond the horizon of peaks like Ruby, Owen, and Baldy in Crested Butte. She was a mixed breed, being comprised mostly of skunk, aardvark, and fruit bat. After fourteen strong, noble, and brave years, Milt has gone to wait at the Rainbow Bridge for her owners, Mark Phwah and Molly Murfee. Here, in her later maturity,

Milt basks in the purple glow of the lupine of Gothic Mountain. Photo by Molly. **TOP** Bunker (background) and Greta at Meadow Creek Reservoir in Tabernash. Photo by human companion Lynn Hanna of Fraser. **BOTTOM RIGHT** Lucca and Mazzie, trying not to look dirty after a romp in their Boulder County yard with a pre-snow soaking. Photo by human companion Jay Kenis.

# Why Have Dogs?

1) When a dog really gets to know you, they still love you.
2) Having a good dog is a great help in learning to enjoy being alone.
3) Does it sound like I have relationship problems?
—Robert Walsh

My dog is ALWAYS happy to see me and that his love comes with no strings attached.
—Michele Wolfe

**Dogs are automatic sleeping bag warmers.**
**—Kristen Driscoll**

Your dog will always be the designated driver!
—Kelly Davis

Because dogs can help heal a broken heart.
—Jill Hawley

Each day when we come home from work, our dogs make us feel like we've been on a long vacation.
—Jim Womeldorf

A dog is a companion and a friend who is always willing to go the extra mile and push your limits, even when your other friends are too busy or lazy!
—Jeffrey Horvat

**Dogs are Zen Masters—they live in the here and now.**
**—Joseph LoGatto**

Dogs: they help get your lazy ass off the couch!
—David November

Dogs know when a hike or ski is needed to clear the mind.
—Lynn Hanna

**As a backpacking companion, I've never once heard my dog complain about, well, anything!**
**—John C.**

To make my desk more popular than the watercooler for shooting the shit at work.
—Matthew Ebbing

Dogs provide the best deterrent to keep other skiers out of your powder stash: poop bombs in the skin track.
—Kirt Hodges

We need dogs for dogless guys on the make to fawn over briefly to impress upon the object of their regard (lust) how kind and compassionate they can be.
—Gary Hollenbaugh

Dog is patient, dog is kind. Dog does not boast. Dog never fails.
—John Coe

Dogs are always happy to see you, no matter who you have been out petting.
—Colby Smith

**Dogs accept us as we are and thereby make us strive to be better.**
**—William Horton**

My dog never has a bad day; he is always happy, full of love, and willing to go on any adventure. Of course it is easy to be like that when you have someone who will bankroll that kind of lifestyle.
—Greg Johnson

A dog is easier to take care of than a baby, yet you can treat him like one.
—Catherine Lutz

My dog is my best drinking buddy. She even swills a brew with me once in a while.
—Michael "Bosco" Latousek

**Unconditional love, baby!**
**—Coop**

# best perch

▲ Zooey the long-haired Chihuahua is the trail-blazer to Tommy and Eva Latousek, always pointing them in the right direction on hikes all over the Colorado Rockies, here in the mountains west of Boulder. ▼ Sophie was rescued from the Pagosa Springs Humane Society four years ago by Will and Nancy Dunbar. Though she didn't start out that way, she is now a great hiking and backpacking companion, always ready to pose for a picture and lie in every creek and stream. This hike was on the Leche Creek Trail in the South San Juan Wilderness. Photo by Will Dunbar. ▶▲ Greta, or Greta-Pie as she is frequently referred to, a Bernese mountain dog, the seventh of a litter of seven, a native hailing from the Great State of Wyoming, has made her home here in Colorado, adoped by Gail and Jim Kreyche of Aurora. She frequents the mountains of Colorado in a tent-trailer as her caretakers are avid campers, hikers, Jim a photographer and Gail a fisherwoman nonpareil. ▶▶▼ Easter was found by human companion Luke Brown on the most-famous day of resurrection wandering the desolate desert 100 miles from man on the brink of demise. Seen here atop Sunshine Peak looking into the Wilson Range.

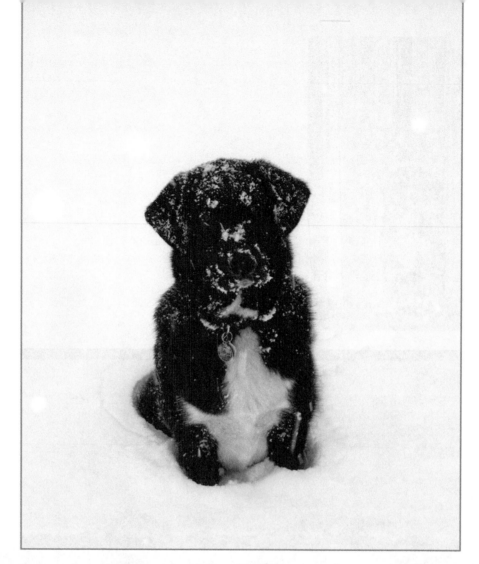

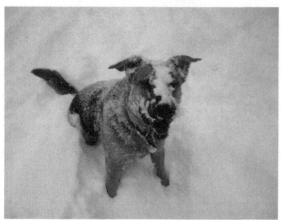

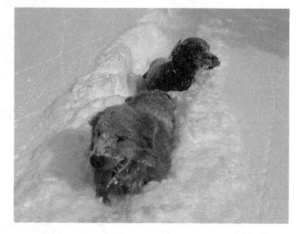

# best in snow

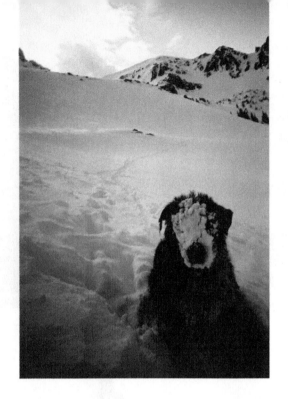

◀ Jackson, a springer spaniel/malamute mix (i.e., a beautiful accident) waits patiently to descend after an early morning ski with human companions Lu Snyder and Todd Alcock at Arapahoe Basin. This April powder day was especially blissful: the very day before, the couple wed in Frisco. Jackson got first tracks and the biggest face shots.

◀◀▼ Dave the Dog waits for the next throw of the Frisbee after a big dumping of Steamboat Springs's famed "Champagne Powder." Dave's other favorite activities are snow biking with brother Grommet and dad Nate Bird, swimming in the Yampa River after tennis balls, and surveying his vast lands from his deck in Steamboat. ◀▼ This photo was taken by me, Russ Austin, while I was solo skiing a great powder day in the Mosquito Range. The golden is Lucy. The chocolate is Colby.

▶ Whiskey dog, doing her best tryout for the role of Petey in *The Little Rascals*. Though she lived most of her life in Ouray, Whiskey was actually rescued by Jeff Bockes from the Animal Shelter of the Wood River Valley, Idaho, where she was awarded the coveted "Pet of the Week" title for being a damn cute puppy. Whiskey enjoyed long walks, even longer skis, and a fine bog water slurp to finish off the day. ▼ Zumi on Webster Pass. Zumi lives in Montezuma with his human companion, Brett Chaffin, son of photographer Karyn Chaffin. Zumi is an Anatolian shepherd who weighs over 160 pounds.

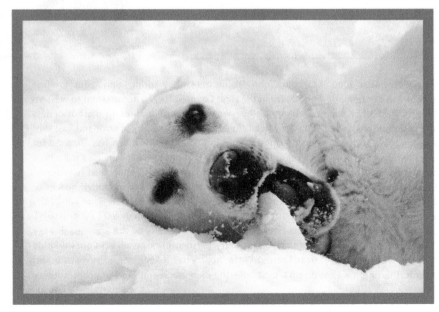

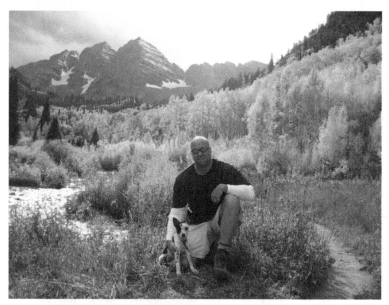

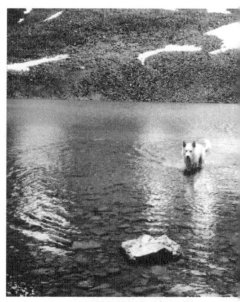

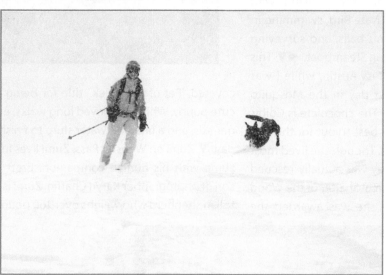

**TOP LEFT** Kacey was three months old in September 2009 when an unknown passerby immortalized her and her human companion, Jake Heffern, at the Maroon Bells. **TOP RIGHT** Kaya skinny-dipping in Sloan Lake on the way to the summit of Handies Peak in the San Juan Mountains. Human companion: Christi Couch. **BOTTOM LEFT** Tucker was born on a horse and cow farm in Chehalis, Washington, in 2007. Sadly, when he was only two months old (human years), he was orphaned by a flood that devastated the region. A nice Olympia family fostered him, but Tucker never could figure out how to be an inside dog. So, in mid-2008, while still a puppy, he joined up with Matt and Leigh Bowe for some off-leash adventure. The threesome cruised the Cascades on foot, bicycle, and skis, but in the winter of '08, starved for sunshine, they migrated to Summit. This photo was

taken by John Valainis of Manitou Springs during Tucker's first good play in the High Country. Tucker, accustomed to western Washington's heavier snows, bounds through the bottomless powder while Leigh Tofte cruises nearby at Loveland Pass during their first winter in Colorado. Not much has changed for Tucker or his family since that photo was taken. He's still a hack on a mountain bike or skis, so he pretty much just runs alongside wherever his masters take him. He's summited dozens of peaks around the state and has a spreadsheet listing all of the types of critters he's successfully hunted. **BOTTOM RIGHT** Roana is assessing snowpack stability as she accompanies her longtime backcountry partner, Buck Myall, on Coney's Ridge near Crested Butte. Roana has a keen sense for hazard and doesn't post-hole the skin track—unlike some backcountry

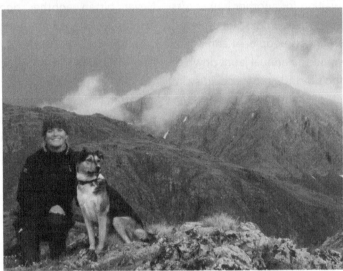

users. She can also find face shots where others fail. **TOP LEFT** Human companion Dana VanVoorhees first met Ella Mae when she was traveling from Moab to New Mexico each week as a travel nurse. Ella was one of the reservation dogs VanVoorhees fed in Shiprock, New Mexico. She lived under a junk car next to McDonald's. VanVoorhees, who now lives in Grand Junction, usually found Ella at the Golden Arches front door begging for burgers and fries along with many other dogs. VanVoorhees fed her and numerous other dogs across the reservation for the entire year she did her travel job. Ella Mae was one of the dogs that she kept telling herself she should nab and find a home for. Of course, she wanted them all. Well, VanVoorhees finally nabbed Ella and they've been best buddies since Christmas Day 2010. VanVoorhees's mom (Ella's grandma) makes her scarves for holiday celebrations and good fashion. **TOP RIGHT** Baxter poses in front of Lizard Head Peak while escaping the heat in Moab, where he reluctantly lives with his human companions Reed and Meghan Kennard. Reed is a trail crew leader for the National Park Service and Meghan is the manager of Bucks Grill House in Moab. **BOTTOM RIGHT** Cally and her human companion, Jen Witt, pause after a mad dash out of the tent during a brief respite from rain during an ill advised monsoon-season High-Country hike near Highland Mary Lakes outside of Silverton. Both Cally and Jen are accustomed to high-desert dry weather and had been doing their best to hide away from the rain all day. Lloyd, the boyfriend and photographer, was able to coax them out with promises that they would not melt, and that the photo would be awesome.

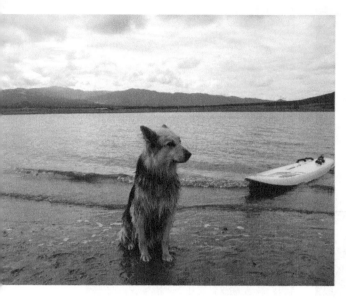

▲ Mingo patiently waiting for another lunker toss on the sandy beach of the Mountain Home Reservoir near Mt. Blanca. Mingo's people—Karin Kaiser and Terry Bickford—made an annual jaunt down to the reservoir for Mingo's birthday so he could swim to his heart's content, dig sand dens, and soak up the sun. ▼ Juno stops chasing marmots for something with gills—Colorado mountain brook trout. "His diet consists of fish. Fish kibble, fish in a can, fish a-la-grill, and fish-in-pill," says human companion James White. Photo taken at Heart Lake, James Peak Wilderness. ▼ Balto emerges from Clear Lake, off Guanella Pass. Human companions: James and Stephanie Lucero. Stephanie took the photo. ▶▲ Bear emerges from a creek north of Purgatory. Bear was adopted by human companion Patrick Savage when he was one. Savage calls Bear the most chilled dog he's ever had, which is good, as he weighs 135. Never bitten another dog even if he's being attacked. Loves all attention and he gets it everywhere he goes. Bear loves water, mountains, people, all other animals. The Savages have a cat and a chinchilla and they all hang out together. ▶▼ Chuska stands in her element in the Pine River. The photograph was taken by her grandparents, David and Nancy Wracher. Her human companions are Andrew Wracher and Jackie Bierie of Durango.

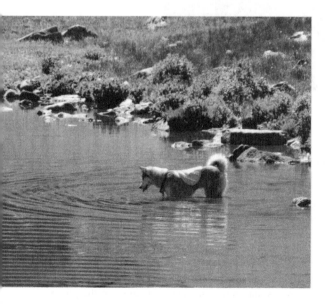

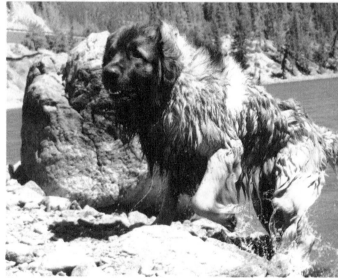

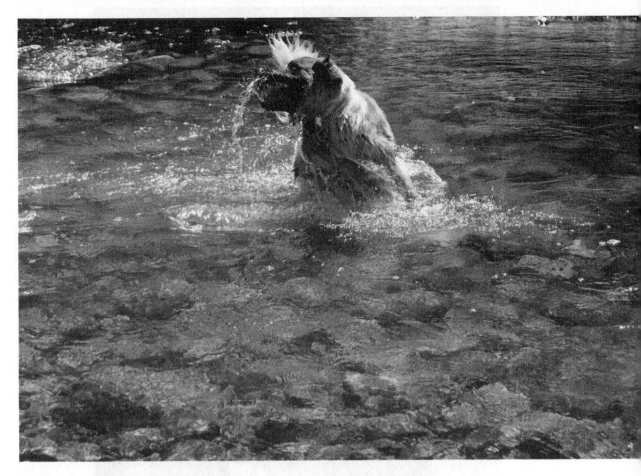

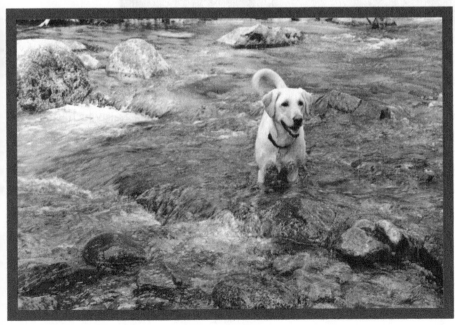

# best water dogs

▲ Eli McFly Puddin' Chicken enjoying the first warm day of summer in Crested Butte, soaking up the sun in the front garden of human companion Shannon Walton in CB South. ▶▲Yoda (foreground) and Daisy cruising through the San Luis Valley. Human

# seize the day!

companions are Alice and Jim Smyth. Picture was taken by Alice. ▶▶▲ After an early morning 4th of July hike up Native Lake Highline Trail, which is on the eastern flank of the Continental Divide near Leadville, Bigfoot patiently waits for a few sips of water from human companion John Seals's Camelbak. Bigfoot's other human companion, Melissa Maestas, took the photo. ▶▼ Kenai on the Continental Divide north of James Peak wondering what could be delaying her ski partners from finishing the ascent. After all, she's already done the hard work of breaking trail through the cornice. Photo by human companion Frank Witmer.

# Dog Trail Running Dangers

**M**ountain trail running with your dog can be hazardous to your health.
It's dusk on New Year's Eve as I crest the hill with Willy. My right foot hits ice on the downhill stride, my left leg hyperflexes under me as I fall, and the tendon holding my quad to my kneecap simply rips away.

There was a minute of searing pain, some muffled yelps, and then I just lie there in the mud and ice thinking, "WTF?"

Willy is eighteen months old. He licks my face, looks at me with concern, and then starts chewing through his harness. Maybe he is thinking, like Lassie, he'll go get help, but, more likely, he is shredding his harness because he is a Portuguese water dog who takes a great deal of pleasure in shredding anything, including shoes, insoles, newspaper bags, underwear, and any stuffed toy we ever bought him.

Sam was an Irish wolfhound/English sheepdog mix born with the craziness that comes from mixing Irish and English blood. He was quick to take offense and respond and smart and calculating in everything he did. He was our first pup and a gift to Blue Eyes and me from her brother Randy.

Sam was a gray fur ball who did well on a leash when we started trail running in the hills above Boulder. He'd occasionally swing around and bite the lead to let me know we weren't going fast enough, but generally he just padded along beside me as if we had been running together for years.

At two years, Sam was running off leash. He would trot in front of me on mountain roads and trails, occasionally looking over his shoulder to make sure I was staying with him.

Because he weighed eighty pounds and was very much his own dog, he had little fear of anything that moved. And while he had developed a healthy respect for cars and trucks, he'd just walk right up to other mountain dogs and greet them—or not—depending on his mood.

Two dogs in the neighborhood were traumatized or trained to be mean. One was a German shepherd mix and the other a hound. Both were about Sam's size. Sam understood these dogs when they charged, pulled-up two feet away snarling and showing mostly teeth. Sam watched but kept his pace. He understood that if he took them on, he'd have to beat both of them.

**Sam. Photo by Alan Stark.**

This went on for months until the German shepherd nipped my hand. Sam was instantly on those dogs like a dust devil with teeth. I danced around in a T-shirt and running shorts trying to sort out 250 pounds of fighting dogs, hoping that I wasn't going to get my nuts ripped off. The fight that ensued was a snarling, snapping, spinning, growling, biting, charging affair that lasted three or four minutes. There was a pause in the action. Sam stood in front of me deciding which dog to charge for the second round, the two attackers stood off warily, then backed away. Thereafter, Sam and I passed by unmolested.

Sam was not only great on the trails. He also loved deep snow. He was mountain smart and knew to take it easy going uphill in powder. In a methodical fashion, he would work his way uphill much like a snowshoer would. He'd pause when he got to the top of the hill, pick an untracked route and then there would be an explosion of gray wiry fur and white powder on his downhill run. Then he'd slowly work uphill and charge downhill again.

We moved to Seattle and Sam gave up trail running at about twelve. From Seattle, we moved to Bainbridge Island where Sam became a kind old island dog with a good deal of vigor that lasted to within three or four weeks of his death at fourteen and a half. After I put him down, I sat on a rock-covered beach with Blue Eyes crying until there were no tears left.

We waited a year after Sam died to get our second dog. Blue Eyes found a dog book illustrated with pictures of several hundred breeds. She decided we should get a Portuguese water dog because PWDs looked like a smaller version of Sam. Mack was a gentle soul, unlike the typical PWD, who are known for kinetic energy, an ability to eat just about anything, and a real love of ripping things apart. Most PWDs will settle into being good dogs at about five or six years old.

Mack was easy to train, always came when called, and while he could counter-surf in the best PWD tradition, he was fairly low energy and never shredded anything.

He was also an extraordinarily good running dog who would drop in right beside me and match my pace for miles. He loved to run free, but, because of draconian Boulder leash laws, Mack mostly ran in a harness clipped to a six-foot lead with a loop that went over one of my shoulders.

That's how we got into trouble. We were out on a five-mile training run with my running partner, Amy, and her yellow Lab, Leah. We were in the last mile through some trees on the South Boulder Creek Trail. It had been a good run and we picked up the pace with the dogs right beside us.

For reasons forever unknown to me, Mack went to the right of a tree as I passed on the left. The lead between Mack and me went immediately taut. The result was painful

**Mack. Photo by Linda Tiley Stark.**

slapstick. We went from an eight-minute pace to zero in about three feet. Mack flew backwards into a heap and I crashed face first to the ground with my right hand in a fist over ribs five and six on the left side.

I just lay there in the dirt and groaned. Mack seemed a tad bit shaken and slightly confused while sitting on my back barking away. It didn't help that Amy was laughing as if she had just seen something from a *Three Stooges* clip, while trying to roll me over.

Amy got me sitting up while still snorting every few minutes, trying to hold back the laughter. My hand was bruised and I had cracked two ribs. I had to force myself to stop laughing, too, because every giggle brought a spasm of pain.

Later in the day, the doc nodded his head sagely and said, "Eight weeks."

"Eight weeks until what?"

"Eight weeks until you can laugh without cringing."

Several summers later, Mack quit running. One hot day, he just stopped at about three miles, sat down, and couldn't be coaxed back into running. He was nine and, as much as he loved running, I should have figured that something was wrong. It was. He died of complications from Addison's disease within eighteen months.

The tendon was surgically reattached to my kneecap. The rehab has gone well. I am months away from blasting down a trail. Willy watches me carefully on walks now as I, against doctor's orders, trot for a hundred feet on my bad leg. He's looking forward to trail running again—so am I.

**ALAN STARK is a reformed book publisher whose past lives included stints with The Mountaineers and the Colorado Mountain Club. He splits his time between Boulder and Breckenridge.**

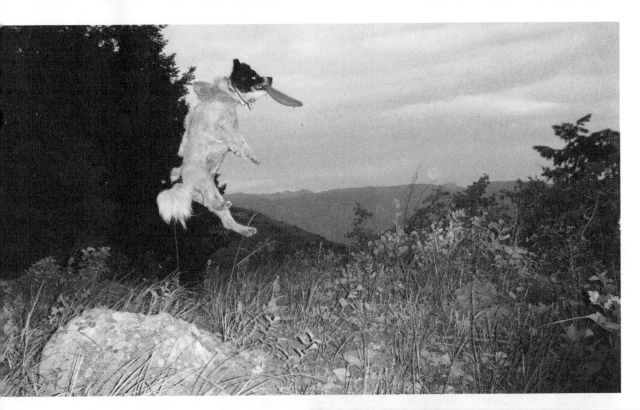

**TOP** On day six of an eight-day, six-state camping trip, human companions Steph Heskin and Jake Mitchell found a perfect spot in Oregon overlooking Hell's Canyon. Steph captured the perfect throw from Jake to Roxy, a border collie mix who was then five. **BOTTOM LEFT** Hunter, an eight-year-old golden retriever/Bernese mountain dog mutt, has been a Summit County resident since he was rescued more than four years ago by Aaron Gregoire and Tara Marie Stanley. Photo taken on Webster Pass by Tara Marie. **BOTTOM RIGHT** Whether riding shotgun on a sea kayak in California or pawing his way up a Fourteener in Colorado, Japhy was a constant shadow of his adopted dad, photographer Jim Womeldorf, of Montrose. Here, he cools down under some rocks in Big Dominguez Canyon. In December 2011, just beyond his sixteenth year of adventure, Japhy drank from his last stream.

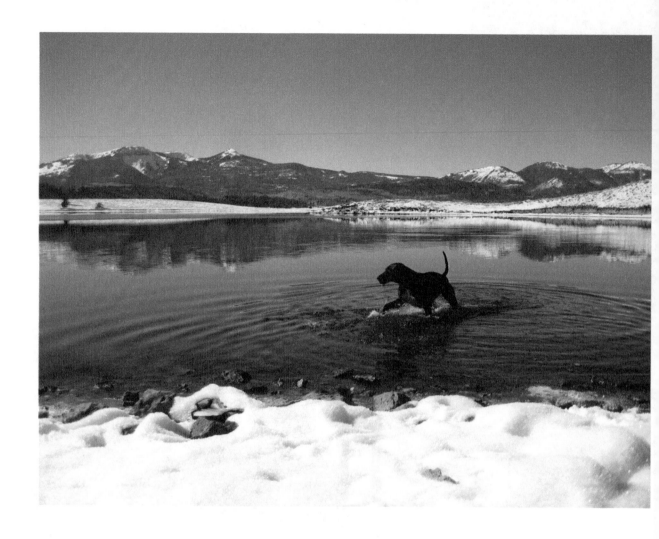

**ABOVE** Enzo enjoys a romp in Steamboat Lake. Photo by human companion Matthew Charity. **TOP, OPPOSITE** Sadie frolicking in Maroon Lake, below the Maroon Bells. Photo taken by human companion Michael Latousek. **BOTTOM LEFT, OPPOSITE** Wili, a Bernese mountain dog who lives in Evergreen, during a June 2006 outing at Dillon Reservoir. Wili was the calm protector of first-time kayaker Ellen Blommel, seventy-six, guided by Wili's human companions, Sheri King and Kevin Bailey (paddling behind Wili). Photo by Pat Smith of Denver. **BOTTOM RIGHT, OPPO-SITE** Dune dog hears his cousins: Batu Khan, a shepherd/chow/golden mix, who lives in Boulder with his human companion, William Horton, listens intently to coyotes howling at sunset in White Sands National Monument in New Mexico. The coyotes were about two kilometers away.

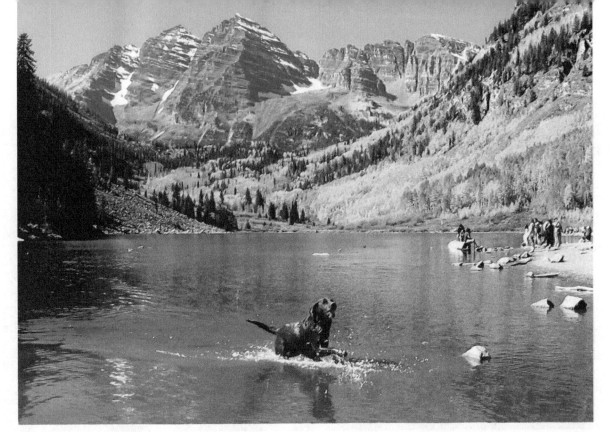

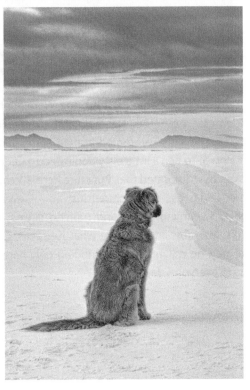

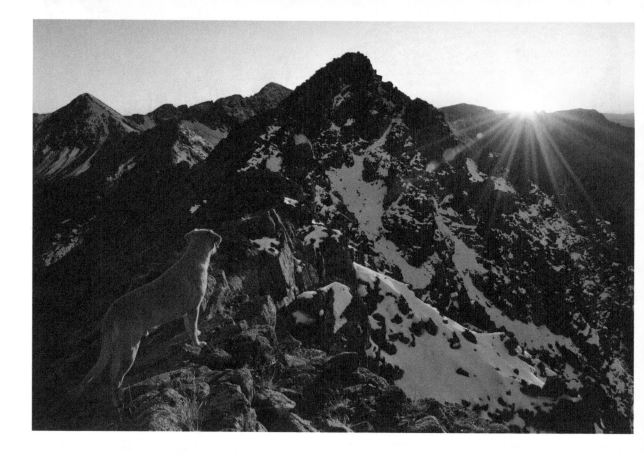

# Most Magestic

These photos of Cedar are from the Weminuche Wilderness, near the Needles and Grenadier Ranges. The series prompted human companion Jeff Horvat to pen a little ditty dedicated to Cedar: Broken this, dislocated that. Puncture here, stitches there. Cedar has been injured just about everywhere. Swimming creeks and running circles up peaks. Marmots and pika are what he seeks. Old and gray, he will never stray. Bringing only happiness to everyone, day after day!

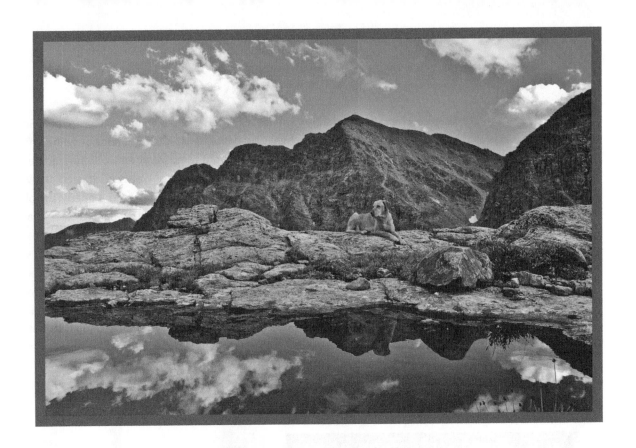

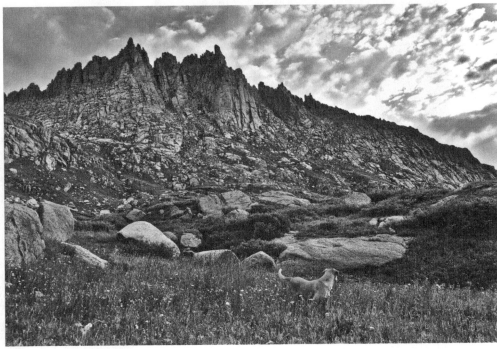

# best zen moment (namaste)

▼ SoBe, a malamute-Siberian child of two madly-in-love sled dogs, didn't r-e-a-l-l-y behave like a dog. In fact, she didn't behave at all. Though she w-a-n-t-e-d to be good, she'd do just about anything for a piece of cheese . . . except obey. Her second-favorite thing was to lie in cool green grass. The real deal. Like you find in cities. Not the funky, wild, mountain varieties of fescues and bunchgrass at 9, 10, 11, and 12,000 feet around Crested Butte. We're talking SOD. She shares her mountain-dog-cool-green-city-grass-revelry with a look directly into the eyes and camera lens of Ryan Boulding, brother of human companion Michele Simpson. ▼▶ Ouzel, eagerly awaiting hikers coming up from the Aspen side of West Maroon Pass in the Maroon Bells/Snow-mass Wilderness. Photo by human companion Shelley Chancellor. ▶▲ After a full day of swimming in the creek, night temps suddenly plummeted below freezing and Bo, a very wet dog, started showing signs of hypothermia. Following a nearly sleepless night and sharing a sleeping bag to keep warm, human companion Diana Ballas awoke to Bo draped in the picturesque rays of the morning sun. If she had to give that image, that very moment a name? "Soul Shine." ▶▼ Guinness, an eleven-year-old Chesapeake Bay retriever who has lived his entire life in Breckenridge, backpacking near Willow Lakes, in the Gore Range, Summit County. Photo by human companion Sterling Mudge.

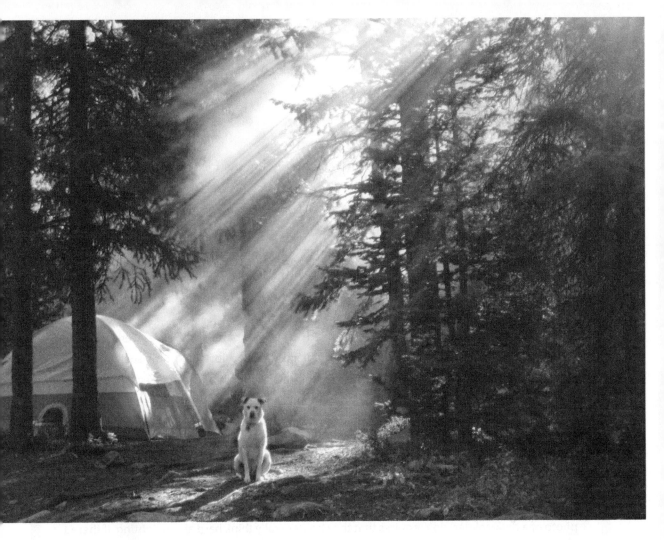

# Tips for Taking Good Dog Photos

Though, when taking pictures of my dog, I personally use the tried-and-true photographic technique known as "crossing my fingers and hoping for the best," the process of sorting through thousands of dog photos over the years has made me understand a few things regarding what makes for a compelling image of Bowser.

Here are a couple of my armchair observations, followed by observations by a couple people who actually know what they're talking about: Mark Fox, longtime photographer for the *Summit Daily News* in Frisco, and David Pfau, proprietor of Breckenridge Photographics and a shooter with more than thirty years' experience under his belt.

• More than any other single reason, I've discarded dog photos because they eyes were not quite right. When you've got a dog out in the mountains, there's a lot going on visually that the shooter is trying to lasso into the frame. There's the scenic vista, the adjacent wildflowers, the babbling creek, and the squirming dog, who is likely wondering why you're stopping on the side of the trail when there's so much more terrain to explore. With all that visual input, photographers often miss the most obvious and most important component of the image: the dog's eyes. If they are out of focus, generally, the photo fails, even if the background is stupendous.

The eyes issue does not just apply to focus; it also applies to lighting, especially if the dog is black, something that Mark and David will get into a bit more. Getting the eyes to pop in a photo of a dark-colored dog requires that the shooter really think hard about lighting. If there's backlighting, either the position of the dog will have to be angled to get more into the light or fill flash will have to be employed.

• Another common deal-killer takes the compositional form of the cutoff paw, tail, top of the head, or mountain summit in the background. This problem is often caused by point-and-shoot cameras that do not have viewfinders that go through the lens—meaning that what you see though the viewfinder is not exactly what the lens is recording for posterity. Nothing to do here except work hard to make sure that everything you want in the image makes it into the image.

• There's no denying that rank photographic amateurs such as myself have benefitted mightily from the advent of digital cameras with numerous automatic settings. Such cameras help people like me mitigate a lack of skills by handing the creative keys over to a microprocessor

and by giving us the ability to shoot 200 frames of the exact same thing without worrying about burning through film. The thing is, these technological advances have also resulted in many people putting the entire photographic process in the hands of the camera. We point, we shoot, we pray. I am of the opinion that, if they are really looking to take home some decent art, people need to slow down a bit, think about metering, f-stop, aperture, and composition the same way they did when cameras had film. Use the technological miracles of modern cameras as a tool, not a crutch.

—M. John Fayhee

## Mark Fox

- Probably the most important thing to remember is to keep the subject front lit when at all possible. Shooting into the sun can create problems.
- Try and separate the subject from the background. A lower camera angle so the dog is above the horizon line oftentimes helps. Make sure the dog does not have a tree right behind it. It's easy to lose the dog in a dark background, especially if the dog is dark.
- Fill flash on the subject certainly helps with black dogs as long as you are close enough to the subject. Or go get a lighter colored dog!
- Unless the subject fills the whole frame, think in grids of thirds, both horizontally and vertically. Horizon line bottom third of frame or top third of frame, never down the middle; subject should also be just off from the center of the frame to one side or the other, which helps create better composition.
- If the dog is moving laterally, pan with the subject, which should help with motion. If it is a really fast dog, enjoy the blur and tell all your friends you were trying to be creative.
- For white dogs in snow, give Fifi a pair of sunglasses and hat and one of those cute little jackets that match the booties. The dog will love you for it and you will be the envy of all your friends when Fifi makes the big time in the *Mountain Gazette* and their dogs are lost in the snowbank.

## David Pfau

*(This is modified from an article I wrote on shooting wildlife for* Professional Photographer Magazine.*)*
Subjects can be divided into two categories: wild and crazy dogs and those under human control. Pursuing both can produce wonderful images. Of course, there's nothing more exciting

than capturing a spectacular image of your crazy dog in its natural environment, but many times it's not possible to capture your dog's best moments spontaneously due to them running up and down the trail. Don't shoot their butt as they're running up the trail, but as they run toward you with that wild look in their eye and the scenery in the background.

### Close-up vs. Environmental

It's not necessarily desirable to always get full-frame head shots of dogs. Including the environment along with an animal gives a sense of place, and if the location happens to be spectacular, then it becomes an integral part of the composition. Still, the subject should be significant enough in the frame to make a statement. Always try to get down low to capture your dog's environment from his point of view. This will lead to a much better shot showing the full dog in its environment.

### Shooting the Right Way: Keep Things Steady

In addition to doing your dog photography in the best light, I strongly suggest using a tripod whenever possible. When photographing with a tripod is not possible, use a beanbag or some other stable support.

Image stabilization lenses, if you can afford them, go a long way to helping wildlife photographers get sharp pictures in low light. They minimize camera movement when you hand-hold them, which in turn gives you more flexibility in your shooting. However, I would still recommend a tripod when it's feasible.

### Shooting in the Winter: Snow and Exposure Problems

*(Excerpt from an article I wrote for* SHOT Magazine *of Denver, now defunct.)*

Winter photography is not so easy on your camera's meter, is it? How many images during winter do we see turn out grayish? Your camera's meter is programmed for 18 percent gray tonal values. During the winter, a portion of the sun's light is reflected off of the snow and into your lenses causing lackluster images. You can deal with this by opening up your aperture by a stop to a stop-and-a-half (on my Nikon, I will generally set my exposure compensation (ev mode) to +1.3 and on my Canon digital system to +1.5 on the compensation dials). The best way in a digital camera however is to produce your own custom white balance by carrying both an 18 percent gray card and a true white balance card to set your own white balance in each and every new shooting situation that occurs. That's why they call us Professional Photographers—right?

Another situation is the dreaded blue snow captured by your camera on sunny days. The snow is a natural reflector and it is simply reflecting the blue sky into your lens. Do not use polarizers during the winter! Use warming/enhancing filters. I will often use a warming filter in these situations such as an 81A or 81C or my new favorite, a warming and enhancing filter, the Tiffen 812. Yes, you can edit in post-production, but is it not easier and it's more cost/time effective to shoot the image right in camera.

**Horton was an ordinary yellow lab living in Breckenridge until he discovered that the Quandary Peak Trail was just outside his door. His first solo hike of the mountain was at the age of two. By the time he was four, his human companions, David and Emily Pfau, no longer tried to keep him leashed up at home. He had the freedom to roam the trail and mountain almost any day he wanted. He came to be known as the "Quandary Dog," as regular hikers of the peak began to recognize his constant presence. Chris Davenport first immortalized Horton in his 2007 book, *Ski the 14ers*. From then on, his fame grew and grew. He was featured on Colorado Public Radio, the book *Halfway to Heaven,* and in numerous blogs and web articles, including 14ers.com. No one knows exactly how many ascents Horton made, but he was known for getting multiple summits in a single day. He once led a hiker to safety through a snowstorm. The man said he couldn't see the trail; he just followed Horton's tail all the way down the mountain. Horton died on April 26, 2011, three weeks before his eleventh birthday. Photo by David Pfau.**

# What Would Jesus Do with a Wild Mountain Dog?

By Tara Flanagan

**T**he note was succinct. "Your dog is always at our house," it said. "We'll take her if you want."

I taped it onto her collar and sent her on her way, having no idea where that was. A couple days later, the kids from the other end of town relayed to us that we had permission to keep the hairy black dog, that she had been biting her owners.

We never bothered to meet Ruby's guardians, figuring they were a bunch of redneck dirtbags who didn't deserve to have a dog. We figured, if the kids were lying, that the dirtbags would find us easily enough; Red Cliff contained about 200 people at the time. If the owners showed up, which they never did, I would tell them what I thought about people who let their dogs run.

"You're a bunch of assholes," I was prepared to say. "Only complete assholes, like you, let their dogs run."

And so, if nothing else, Ruby moved into our house to reaffirm one of life's key tenets: We all are assholes in relative terms. If you look at the Ten Commandments, that's what they're saying. Don't steal other people's crap, don't have crazy drunken sex with your neighbor's spouse, don't let your goddamned dog run all over town, but don't judge those who do. Jesus Christ went to the cross as a reminder that we all need to acknowledge our inner redneck dirtbags.

In this case, Ruby continued to run. A closed door meant it could be opened. A locked door meant breaking through the nearest window. Shock collars only meant that wildness will always prevail over technology or anything else we humans offer up. Wildness is why the Ten Commandments didn't work out so well. It's why cockroaches and thistles will reemerge if we manage to nuke or otherwise choke out the planet.

It might be the reason we stayed in Red Cliff for eleven years when we had planned to stay only as long as it took to find another place to live. It became a place where our wildness could stay in us a little longer, before we lost our souls and moved to Planned-Unit-Development subdivisions, or worse yet, became Planned Unit Developments ourselves. We drank more than most people, howled at the moon, and some of us were on drugs. We scoffed at the people over the mountain in Vail, let our old cars rot in our yards, and our dogs ran as if someone had paid them inordinate sums to not get caught.

**Ruby. Photo by Greg Wright.**

Ruby would disappear for hours and sometimes days, roaming the potholed streets and alleys and occasionally retreating to the mountains that surrounded town. One year, she left for the three days after Thanksgiving, after she had devoured a quart of turkey grease and other remnants from the roasting pan. From a digestive-debacle standpoint, it was just as well. When our son was born, she left home and established rooming privileges at the neighbor's house, teaching their dog, Ezra, the intricacies of running. Things like speed, direction, and how long to safely stay in one place. People you can trust and those kinds of things humans might never learn.

**Leisel. Photo by Greg Wright.**

I knew that Ruby would be a very old dog before her wildness would fade. We had long since moved to and, alas, become Planned Unit Developments when it was clear that her time had become short. At seventeen, she could barely walk or stand, and like us humans when we are horrifically old, she spent most of her time in a dazed half sleep—a couple toes testing the waters of the afterlife. A time when everything is done and there is no apparent need for wildness. Or maybe your time is done when you lose your need for wildness—there's a difference.

Still, we continued to duck out on that last trip to the vet. If there is a definition of the worst day of your life that does not include saying good-bye to your old dog, I'd like to know what it is. (No I wouldn't.)

Because we were and continue to be assholes on some level, we found another dog—a blue heeler named Liesl—while Ruby was still alive. I told myself that perhaps her part-time residence in the afterlife—the same way she lived at the Wilson's house in Red Cliff after our son was born—gave her an arm's-length understanding of the rude and unacceptable things we did, like bringing home new babies and dogs.

Liesl hadn't been in the house for fifteen seconds when my philosophy died. Ruby leapt to her old feet and with the wildness of a dog one-tenth her age, proceeded to beat the hell out of Liesl. The new dog yelped crazily and ran to a corner while Ruby collapsed back onto her place on the floor. The beatings resumed as often as Ruby could recharge herself.

Maybe it wasn't rage on her part as much as it was a lesson to the new dog. Hang on to those things that make you fly. Learn about direction and speed, people you can trust. And run wild while you can.

**TARA FLANAGAN is a longtime newspaper reporter with stints at the *Vail Trail*, the *Granby Sky-Hi News*, and the *Summit Independent Daily*. She lives in Breckenridge.**

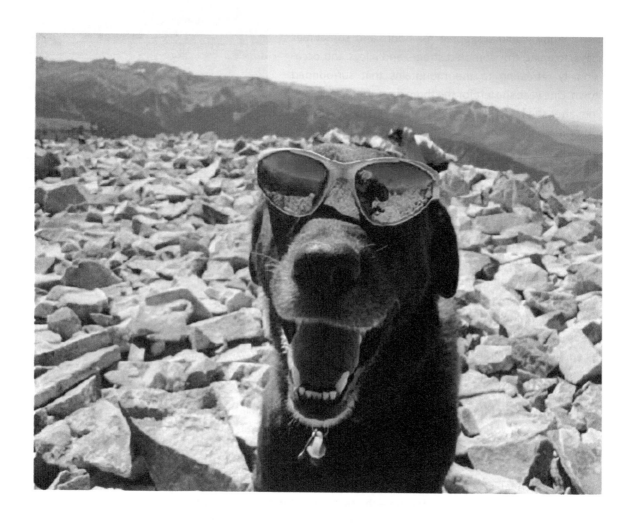

▲ Bwana on the summit of Mt. Sopris reflecting his human companion, Mark Fischer, with his other

# class clown

human companion, Lari Goode, in the background. ▶▲ Toby, in the red jacket, and Skip love to play furiously but harmlessly. Skip is owned by Aurora Wright, while Toby is owned by Beverly Compton (who took this photo), both of whom live in Pagosa Springs. Toby came from the Farmington, New Mexico, animal shelter and froze his first winter in Colorado—the reason for the dog jacket. ▶▼ Zurry and Riker were hiking on Tomboy Road outside Telluride with human companions Nancy Heim and Lucinda Carr and they were having a little trouble with their long hair falling into their eyes. With no hair clippers or scissors close at hand, photographer Amy Levek, who always carries something for her hair, was more than happy to lend the elastic to the dog.

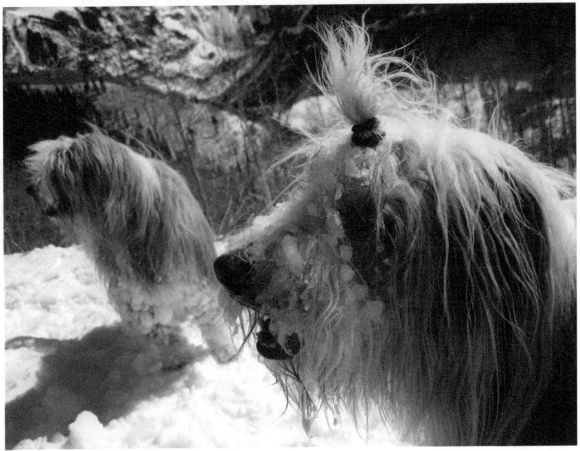

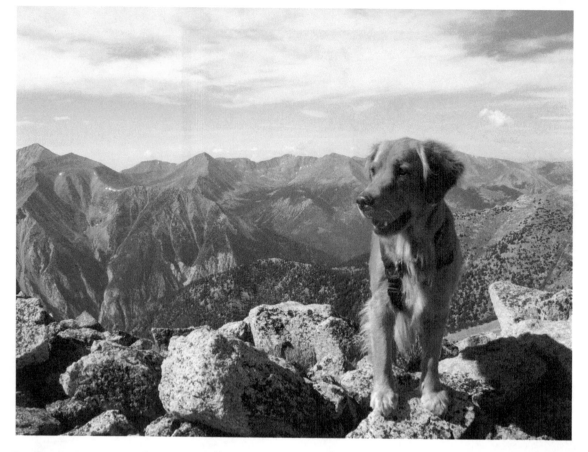

# high climbers

▲ Rodeo on the summit of 14,197-foot Mt. Princeton. Human companions: Diane and Mike Smith of Silverthorne. Photograph by Diane Smith. ▶ The mighty Peanut, a six-year-old half-Chihuahua, half-French bulldog, all-mountain cur, owned by Jasmine Listou Bible, on respite from the rigorous Iditarod training circuit, takes time to climb a nearby boulder at his home in Summit County. ▶ Buddy on Peak 13,309 overlooking Clear Lake (east of US Grant Peak—Ice Lakes Basin). Photo by human companion Brett R. Davis.

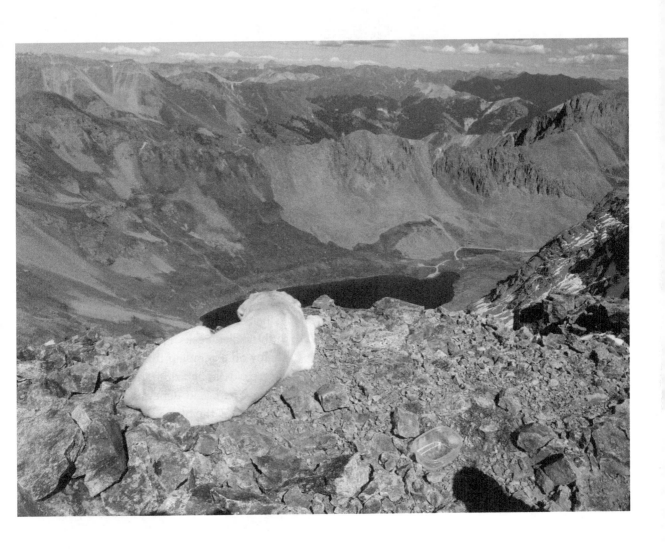

▲ Otis, smashed after a long day in Crested Butte gallivanting outside with his human companions, Capp family—Ryan, Maria, Sophie, Ben, and Ethan. There were moose face-offs, stream bathing, and mud wallowing (note: mud after water). ▼ Carter Marshall atop Pikes Peak on July 4. After a tough summit hike, Carter had a few celebratory cans. Human companion is Joni Fournier. Photo by Matthew Yurkovic. ▶▲ Hazel, whose human companions are Sage and Dale Case of Louisville, catches her breath after hiking down to Pawnee Lake in the Indian Peaks. Photo by Paul Andrews. ▶▼ Shelby on a camping trip near Comb Ridge, Utah, after a big day of hiking. Shelby lives with her people, Peg Sharp and Renee Brown, in Crested Butte. Renee took the photo. ▶▼▼ Malibu in the lawn chair on the deck of her human companion, Sue Feldmann, in Frisco.

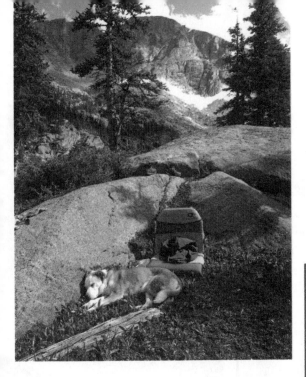

well-earned repose

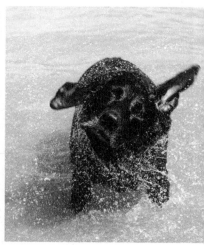

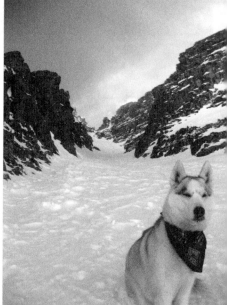

**TOP** Buddy shakes off after a dip in Old Dillon Reservoir in Summit County. Buddy's human companions are Barb and Chloe Bailey. (It's a grandmother/granddaughter thing.) Photo by Bob Winsett. **BOTTOM LEFT** Pikabu wanders a lonesome highway outside Norwood, with Cindercone Peak in the background. Human companion: Trevor Hertrich. **BOTTOM RIGHT** Avery at Naked Lady Couloir, Snowdon Peak, San Juan Mountains. Shreddin' couloirs at seven months old with human companion Max Kugel. **RIGHT, OPPOSITE** Inde was discovered on Craigslist and brought home by human companion Colby Smith when she was nine weeks old. This photo is from when she was around nine months and is one of Inde's first camping trips on Shrine Pass. When this photo was taken, Smith was making an effort to keep Inde from entering the stream behind her. She had turned and given him a quizzical look when her name was called, but ultimately, the efforts were in vain, as you can't keep a water dog out of the water.

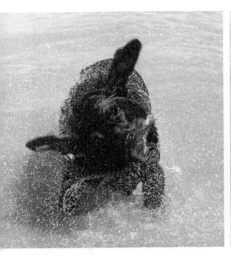

RACER'S EDGE

WONDERBUMP

POWDERKEG

SHOWDOWN

YOO HOO

▲ Zoe of Grand Junction is an ordinary mixed-breed (okay: mutt) dog but, in the great outdoors, she is an awesome skier. After hiking up, Zoe enjoys fresh post-season snow and sunny conditions while cruising the black diamonds of Powderhorn Ski Resort in Mesa with her human companion, Kristen Ashbeck. ◄ Muna loves running on the trails of Ouray. At sixty-five pounds, Muna is a persistent lap dog and climbs into Emma or Joe Benenati's lap whenever or wherever they sit down and whether she fits into the chair or not. Photo taken above Ouray.

# most ambitious

▲ Slinky, a shepherd/mutt mix, plunges down the Ridge of Bell on Aspen Mountain on a snowy November day before the mountain opened to the public. A rescue dog who has lived most of her life in the Colorado mountains, Slinky enjoys powder days almost as much as her people, Catherine Lutz and Mike Sladdin of Aspen. Photo by Chip Strait. ▲▶ Klaus was rescued from a shelter in Plano, Texas. He was said to be wandering down a Texas interstate, likely abandoned on the side of the road. After driving thirteen hours to pick him up, human companions Judson and Tara Miller, of Golden, found him to be severely underweight from intestinal worms and flea infested. He was on the VIP list, meaning he had worn out his welcome at the shelter and would be euthanized that week. Adoption fee: $25. Klaus ended up putting on forty pounds, and was strong as an ox. The picture with him carrying bags was taken on Mt. Galbraith west of Golden. It was his favorite place to be. The rock he is standing on was his favorite place to sniff the wind and survey the valley for deer. A year after this photo was taken, Klaus was diagnosed with bone cancer. After six months, the Millers were forced to amputate one of his front legs to help relieve the pain. He was indomitable even with three legs. Sadly, the cancer caught up with him four months later and overtook his lungs. Klaus left this world in May of 2011. Judson took the photo.

I

# Reginald and Perro

By M. John Fayhee

**When you live, like I did** for almost a quarter century, in the heart of canine heaven (read: the Colorado High Country), you get used to viewing dogs in fairly optimal lifestyle circumstances. You see generally well-fed, well-attended dogs cavorting in snow, rivers, and lakes. You see them along hiking trails and ski tracks and relaxing in tents, in front of campfires and at the base of climbing walls.

It is, therefore, sometimes a bit of a shock when you travel and witness the sad reality that, in many places, maybe even in most places, the lives of dogs are not up to High Country snuff.

For many years, I traveled often to a place called Las Barrancas del Cobre—Mexico's famed Copper Canyon Country—located near where the states of Chihuahua, Sonora, and Sinaloa come together in a jumble of astounding topography that is unrivaled in the Western Hemisphere. This area is home to the famed Tarahumara Indians, known the world over for their long distance–running acumen.

My wife, Gay, and I spent two months in 1988 working on a backpacking guide/travelogue about the Barrancas.

The owners of a hotel south of the town of Creel, generally considered the main jumping-off point for excursions into the canyons, graciously allowed us to establish a base camp on their property. This was not exactly a private spot, but it did afford us easy access to the hotel's various amenities, including a restaurant, bar, showers, and socialization with people besides ourselves.

The place where we actually erected our tent—home sweet home for sixty-plus days—was a stone's throw from diminutive Cusarare Creek, alongside which ran a prominent path to one of the most-visited tourist sites in the entire region: Cusarare Falls. Consequently, there was much in the way of foot traffic, both of the gringo and indigenous varieties, as local Tarahumaras would set up shop at strategic points next to the trail, where they would purvey arts, crafts, and snacks to passersby. It is near-bouts axiomatic that, where there are Tarahumaras, there will be Tarahumara dogs. Lots and lots of dogs.

The Tarahumaras are goatherds, and their dogs earn their kibble (usually a mix of corn and lard) by helping keep the goats in line, which is just one small organizational step above herding cats.

By Colorado High Country standards, the lives of Tarahumara dogs are short and brutal. They are not vaccinated. They are not spayed or neutered. They are not coddled. They definitely do not sleep on $120 Eddie Bauer beds indoors next to the heater. But, compared with many Third-World places I have visited (rural China and Africa come to mind), the dogs in the Copper Canyon area seem fairly healthy and well adjusted.

One of the ways they survive is by taking advantage of the soft hearts of gringos

strolling through their home turf. The dogs living near Cusarare Falls congregate in the hotel parking lot, awaiting the arrival of the tourist buses, which disgorge dozens, sometimes hundreds, of snack-laden visitors every day. At that point, the local curs go into character. They display an astounding range of acting abilities. Simultaneously, they are able to gleefully frolic and bound down the trail at the feet of their potential benefactors, as though they were the actual pets of people from Europe, Canada and, well, the Colorado High Country, while, at the exact same time, they are able to put on a very real method-acting-like sad-starvation face once the trail snacks started getting pulled out. Few are the people who are not swayed enough to share their sandwich with the Tarahumara dogs as they lay their cute muzzles upon $300 hiking boots imported from Italy.

**Poor Sonrisa—aka Reginald—had such a distended jaw that it was hard for him to eat the food we gave him whenever we camped at Cusarare. He was a sweet little dog. Photo by Gay Gangel-Fayhee.**

The fact that Gay and I hung out near the Cusarare Falls trail for most of a season complicated the dog/snack/sad-face situation somewhat. But not in the way we expected. We had only been on scene for a day when we were officially adopted by a local dog that did not seem to be associated with an actual Tarahumara family. This dog was a pitiful sight. He had front legs calcified so badly that he was unable to walk normally; he was, instead, forced by physiological circumstances to hobble stiffly and miserably. And he had a lower jaw deformed so badly that his lower teeth perpetually protruded. He could not close his mouth all the way. This poor animal was called *Sonrisa*—"Smiley"—by the employees of the hotel, who, to their credit, did provide him with occasional meals.

We called him "Reginald" because it sounded dignified and this was a dog that seemed like he could use a bit of dignity in his life. Whenever we were in camp, Reg was there, lying near us because it hurt too much to walk, stand, or even sit. When we built a fire, he crawled close to it. We always made extra food and shared it with poor Reg, and, weirdly enough, the other dogs left us alone. It was like they felt sorry for their handicapped compadre and did not want to interfere with his newfound good gringo fortune. Whenever we left to go on a backpacking trip—sometimes for a few days, sometimes for a week or more—we always fretted about Reg. And, when we got back, he always

appeared, limping his way out of the woods, wagging his tail as best he could. It did not matter what sort of food we laid before him—cream of wheat, dried fruit, instant soup mixed with instant rice—he always ate it, and we could tell from the look on his crooked face how much he appreciated our kindness.

We started having an unavoidable conversation. We started talking about maybe bringing this sad little dog with us back to Colorado, where, with proper treatment and diet and love, he could live out his years in comfort.

## II

The Barrancas del Cobre area is accessed by one of the world's most-famous trains: the Ferrocarril Chihuahua al Pacifico. Though an astounding number of vapid travel-magazine articles have, over the years, described this as a train route that passes *through* the canyons, it does not. Matter of fact, there is only one place—named Divisadero—where passengers can even glimpse a view of the canyon depths. The train stops at Divisadero for fifteen minutes so people can get off to snap a few quick photos and buy some gorditas and trinkets from the trackside vendors whose entire livelihood is based upon the fact that, twice a day, trains come in from the east, and, twice a day, trains come in from the west.

I had long wanted to hike from Divisadero to the opposite rim, an excursion similar to hiking between the North and South rims of the Grand Canyon, except that there were no trails. Gay and I decided to make that arduous on-foot journey as part of our book research. We hired a Tarahumara guide we had already worked with a few times and took the train from Creel to El Divisadero.

No sooner had we cinched our packs than a large black dog with a bobbed tail glommed onto us. We assumed he lived somewhere nearby and, like the dogs at Cusarare Falls, made a large part of his living begging for chow from passing gringos. We assumed he would stay with us for a half mile or so before returning to the train stop at Divisadero. We assumed wrong. The dog, which we creatively named *Perro* ("dog" in Español), stayed with us as we made the ten-hour, 5,000-foot descent to the bottom of Copper Canyon. He stayed with us as we crossed the mighty Urique River. He stayed with us as we bush-whacked our way through dense undergrowth for two solid days as we dragged our beat-up carcasses to the far rim. He stayed with us as we dragged our beat-up carcasses back down to the Urique and back up to El Divisadero.

All told, Perro stayed with us for almost a week, during which time we shared a quarter of our rations with him—much to the chagrin of our perpetually hungry young Tarahumara guide—just like we would have had Perro been our own dog. Which, for that time, he was. And, of course, during that week on the trail, Gay and I had, yet again,

an unavoidable conversation. We knew there would be some logistical problems if that conversation reached what was by then a foregone conclusion. Since we had taken the train to Divisadero, we would have to come back to get Perro, which would be doable, as there was a road—albeit in those days, a rough one—from Creel to Divisadero. But who knew if he would still be there when we got back? We couldn't just abandon him after all we'd been through!

Or, we thought, it would only take me a week or so to hike from Divisadero to our camp at Cusarare. Maybe Gay could take the train back to Creel, and Perro and I could walk back together to Cusarare. We knew it would be tough to get Perro back to Colorado because our truck did not have an extended cab, and the camper-shell-covered bed was full of gear. Plus, we had no idea what red tape we would encounter at the border if we showed up with an illegal-alien mongrel in the back of our truck. Plus, there was the unavoidable fact that we did not at that time have what you could technically call a home. All of our belongings were stored in the basement of Gay's parent's house in Colorado and we had not yet arrived at the point of ascertaining where we would hang our hats when we returned to the Centennial State. But, we figured, where there's a will, there's a way. Besides, we figured, Perro needed us!

As we were dialoguing about how we could orchestrate getting Perro home, Gay asked, eyes wide, jaw agape: "What about Reg?" So, that chat suddenly became even more complicated because, well, we couldn't very well take Perro with us while leaving poor Reg behind! What kind of awful people would do such a thing?

One of the most interesting aspects of talking to people about their dog(s) is hearing the acquisition/ bonding stories. B. Frank got his dog, Christy, while he was lying on the ground working on his broke-down car on the side of the road outside remote Reserve, New Mexico. As he did so, a dog he had never seen before that moment materialized and lay down next to him. And they've been together ever since.

I got my last dog, Cali, at the Summit County Animal Shelter in Frisco. I had been looking for a dog for numerous months, but I wasn't going to take that leap

**Since we were conserving film, this is the only photo we have of Perro. Taken on the non-trail down from Pamachi with the Rio Urique far below, this photo shows the difficulty of getting exposure correct at midday in canyon country. Photo by Gay Gangel-Fayhee.**

unless there was some sort of bond, an unmistakable spark between quadruped and biped. I went by the shelter numerous times and stoically and dispassionately walked from cage to cage, eyeballing and sometimes visiting with the forlorn occupants, psychic antennae probing the atmosphere for a connection that never did occur. (That process was made easier because the Summit County Animal Shelter is essentially a no-kill establishment, so it wasn't like I was sentencing any dogs to death by not taking them home.)

Then, one day a photo appeared in the Pet-of-the-Week section of the *Summit Daily News*, where I worked as an editor. That photo, not un-coincidentally taken by my best buddy Mark Fox, was of a four-month-old, jet-black half-German shepherd/half-Australian shepherd named Cali. That photo and the face framed in that photo spoke to me loudly enough that I immediately went to the shelter and, by the time I left, the staff was already referring to Cali as my dog, even though several other people were very interested in taking her home. We were inseparable for the rest of her thirteen years, right up until, a week before B. Frank and I were set to drive down to a place called Copper Canyon, Cali succumbed.

Gay and I both thought the idea of having two dogs saved from the vagaries of life in Mexico while we were down there working on my first book project would be pretty cool. The fact that we liked both Perro and Reg, and they seemed to like us, was icing on the relationship cake. And it would be an interesting canine twosome: Perro being large, athletic, energetic, and gregarious and Reg being a small, shy cripple. Mutt and Jeff. Big brother hopefully looking after little brother.

When we finally slogged our tired selves back up to Divisadero, Perro ran off. We assumed he was merely checking in with his old turf, perhaps saying good-bye to his muchachos before embarking upon the rest of his life, which would unfold in a mystical place called Colorado. But, no, it was more than that. Perro apparently figured the backpacking trip with the gringos was over, so it was time for him to return to his old foraging ways. I went over to him, and it was as though he had never seen me before. It was shocking and a bit humbling, as I groped with potential proper reactions to having stereotype-based assumptions tossed back into my face.

A relationship between human and dog is a two-way street and, though it sure seemed as though Perro liked Gay and me well enough, maybe he didn't feel the kind of bond I found when I met Cali years later. It was the height of hubris to think that, just because we were affluent (relatively) Americans who boasted a limitless supply of chow within the bowels of our overstuffed backpacks, Perro would automatically want to attach himself to us for the rest of his life. That's not how it works. At least not all the time. Dogs are not complete without a human companion. But Perro's human companion might very well have been a Tarahumara living down in the depths of Copper Canyon. Or it might have been the next gringo leaving for a weeklong backpacking trip.

Either way, the last time we saw Perro, his ass was sticking out of a fifty-five-gallon-drum trashcan. He seemed like he had found something tasty, because, try though I might to gain his attention by asking him if he wanted to come home with us to the Rocky Mountains, he did not react. He was probably there, with his head buried in garbage, wondering what on earth he needed to do to get rid of the gringo. He was probably wondering why I couldn't take a hint.

## III

Reg was waiting when we got back to our camp next to Cusarare Creek, and he was waiting there every time we returned for the next month.

On what turned out to be the last morning of our trip, the weather turned nasty and cold, this being at a 7,300-foot elevation a week before Christmas. When we dragged our shivering selves from our tent, we found that some manner of critter had torn into our food bags, which we had left leaning against a rock right outside the tent. Sitting nearby was Reg, looking guilty as hell, his tail between his legs, with evidentiary crumbs stuck to his lips.

I was in a bad mood. We had been thinking about taking one more backpacking trip, but, with 1,000 or so miles under our belt already, we decided it was time to go home. Reg apparently knew he was in the doghouse, so, while we were packing up, he slinked away. We noticed his absence, but did not seek him out. We had stopped talking about bringing him home after we learned how difficult it would be to get an obviously infirm dog across the border. In a way, we were relieved. Still we wanted to say good-bye. We wanted to load him up with one last full belly. But we did not see him again.

When I next visited Copper Canyon a year or so later, I asked about Reg. Everyone at the hotel shrugged. They hadn't seen him since, well, since about the time Gay and I abandoned our little camp there next to Cusarare Creek. No one knew what had become of him.

◄ The shot was taken at the Division Wall, American Fork Canyon, Utah, in autumn 2007, and is of Clyde, who after a long day on the road to get there and then being dragged to the cliffs while human companion Matt Samet, a Boulder resident, climbed, found a nice crack to curl up in and take a nap, putting geology to work for him. Photo by Mark Niles. ▼ Long Fellow, Sweet N'Lowe, and Lickidy Split snow-skating with Dennis down East Eighth Street in Leadville. Photo by Scout Sorcic.

# most game for anything

▶▲ Rachael, who belongs to Ms. Deanna Lorenz, runs with Mags near Cotopaxi on Mother's Day, when they let the horses out to graze the Terra Christie Ranch for the summer. The magnificent Sangre De Cristo range provides the backdrop. Photo by Michael Glenn Cooper of Salida. ▶▼ As a pup, Buddy ate $250 of the neighbor's chickens, was in turn handed off to a dogsled team, where his 100-pound malamute size and joie de vivre were too much for the much smaller huskies, and finally was pawned off on human companions Ray and Lisa McDaniel at around nine months. Buddy signed on many class two and three peaks from the Sierras to the San Juans. Bud would cry when he knew it was time to head back to the truck. A double-black-diamond-scrotum skier if ever there was one. ▶▶▼ Juno, out for a stroll with her human companions, Lisa and Klem Branner, above Stony Pass near Silverton. If Juno can't find a live porcupine to fill her mouth with quills, she will settle for rolling around on a dead one.

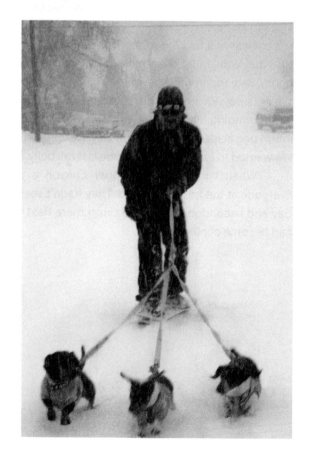

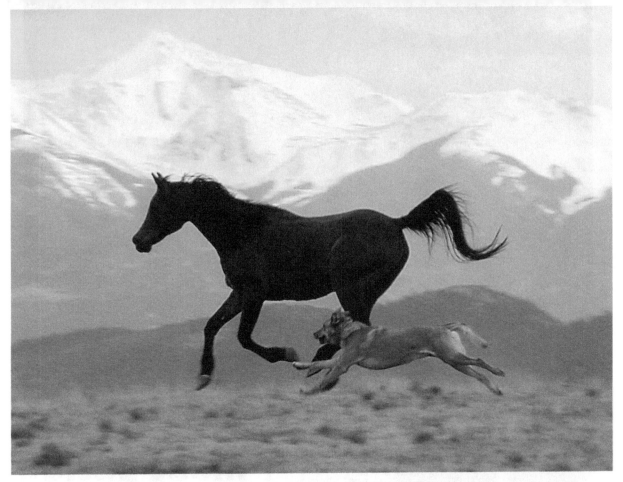

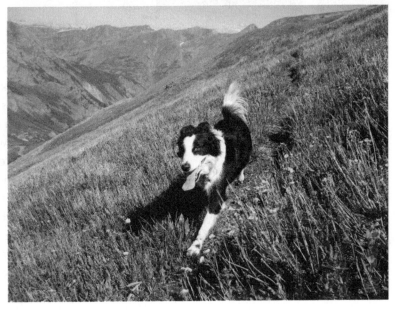

# most patient

▲ Duke staying dry in a rainstorm, while keeping a safe distance from the fire on the Colorado Trail. Photo by human companion Kelly Bulkley. ◄ The photo of the Great Pyrenees was taken out the partially open window of a moving vehicle in Red Cliff when it was snowing. Photographer Michael Glenn Cooper returned a year or so later and found out the dog's name is Murphy, but the owner was not to be found. Cooper gave a framed copy of the photo to a friend that let him display his photos in his Salida restaurant and it made him cry; he said it reminded him of home (Boston?), a dog waiting for his master to return from the sea.

▼ Ten-year-old Sierra enjoys some bonding time with Ian Morrison on a hike above Over-land Reservoir in western Colorado. While Ian is a far cry from a sheep, Sierra has taken well to baby herding. Photo by human companion Leah Morris of Paonia.

**Dog Years—A Life** By B. Frank

**M**any dog lives ago, Russian scientist Dmitry Belyaev started collecting foxes from fur-breeding farms in Siberia. He was testing a hypothesis that genetic change would turn offspring of "wild" animals into tame ones in a single human lifespan, in an accelerated version of Darwinian natural selection. The offspring of Belyaev's foxes were screened for gentle behaviors, and aggressive puppies were sold back to fur farms.

Later that same year, on another continent, an eight-week-old puppy popped his fox-like head out of a winter jacket that smelled of stale sweat, beer, cigarettes, and wood smoke. He skittered across the floor with ears pricked and tail curled toward a bedridden child, who opened his eyes and laughed out loud. The puppy had a black-and-tan coat with underfur that shed snow and rain. He slept through Colorado winter nights with nose buried under furry tail, and devoted his long dog life to protecting the child from real and imagined dangers on rambles across a mountain landscape that shaped the child's adult life.

Within a few fox generations, some of Belyaev's pups curled their tails up, rolled on their backs when approached, followed their human caretakers, and had multicolored fur never seen in fur farms, or wild foxes. After Belyaev died, his protégé became head of the scientific center he started, and the experiment continued. Scientists from around the world looked for "domestication genes" in Belyaev's foxes, but so far have been unable to create a genetic map of fox domesticity. According to several researchers, such findings could lead to insights on how humans became different from other primates, both physically and behaviorally.

In behavior and ability, each of my own dogs has matched my interests and activities for that period—or each dog has shaped my behavior to their own needs and desires. By one telling, some wolves that scavenged around early humans' camps had genetic mutations in their brains that led to less-aggressive dispositions, which led humans to welcome their presence. This is known as "cognition theory."

In other words, as some wild hunter/gatherer-type humans tamed themselves into civilizations by socializing instead of fighting each other over food, some wolves adopted humans as providers of food scraps, learned to observe signals from their human benefactors, and eventually domesticated themselves into dogs that use humans as tools for solving food-supply and shelter problems. Twenty years ago, an American scientist named Brian Hare started testing cognition theory, pretty much by throwing a ball and hiding food for his dog to find, then pointing in the proper direction. He found that dogs watch and cooperate with human hand signals, but wolves do not.

Recent genetic mapping by Chinese scientists confirms that dogs also have genes that in human brains are associated with cooperation. No word yet on whether Belyaev's foxes are being tested for the genes found in the Chinese study (or for the cooperation skills Hare documented), but it just may turn out that many generations of fur-farm-refugee foxes have managed to train two generations of scientists to provide food and shelter for their offspring, by observing their human captors' reactions to wagging tails.

My current dog looks like a red fox on steroids. Now fifteen-plus years old, she's periodically buffeted by health crises, but, on most days, still wags her tail, runs in circles, grabs the leash from my hand, and rolls on her back to be petted, leash in mouth and what I swear is a smile on her graying face. I've been through all this before. First with the black-and-tan dog my dad brought home one cold Colorado night, then with a yellow dog that followed me on rambles into canyons, over mountains, and from one coast to the other, in a period when neither of us had much reason to look back at our past lives.

Thing is, I've never looked for a dog in my life—never had to, because stray dogs have found me. The black-and-tan one and I grew up together until the trajectory of dog years and human years diverged. The yellow one found my doorstep one winter, stayed until I let her inside and died in my arms fifteen years later. The red one hitched a ride out of a mountain town that treated dogs as disposable pests, and she still steers my behavior whenever she gets a chance. For a couple of years, I've talked about finding a younger dog for my red dog to train, just as she was mentored by my old yellow dog, but no candidates have caught my eye so far.

While none of this wolf/fox/dog/human behavioral science research addresses the problem of finding a young dog for my old red friend, it does make me eye the way

**Christy relaxes in a field of Colorado wildflowers. Photo by B. Frank.**

highly domesticated humans and dogs tend to socialize, and then turn to using their associates' cooperation to line their own dens. For a fee, I could enlist one of a pack of variously pedigreed dog rescue organizations, or "adopt" a Siberian fox. To help finance the fox experiments, some descendants of Belyaev's pups are available on the American market.

In the meantime, a startup company offers a chance for dog tools to become data points. For $99 year, I can download behavioral quizzes for my old red dog, and the results will provide data for the next phase of Brian Hare's cognition experiments. This seems a little expensive to have my dog's (and my own) behaviors data-mined, but considering that the going rate to adopt one of Belyaev's foxes is hovering around $9,000, crowd-sourced cognition science seems pretty cheap.

In my experience it's been much cheaper and more satisfying to be a stray dog's tool, which may lead to me waiting for another one to pick me out of the common herd of human behaviors, and come with me through one more semi-feral life in dog years.

**B. FRANK is the author of *Livin' the Dream: Testing the Ragged Edge of Machismo*. He splits his time between the Four Corners area of Colorado and the Border Country of Arizona.**

# Don't Worry, Cujo, Fang, and Warg Are Friendly

## Warning: You are now entering an overt and shameless didacticism zone.

For most of my adult life, I have lived in places where, despite the prevalence of dogs and their companion humans, and despite the fact that many of those humans and dogs venture forth together into very public places, such as hiking and cross-country ski trails and town parks and the patios of High Country watering holes, only a small percentage of those dogs are even slightly "trained."* This reality is a bone of contention with a great many people, some of whom are dog "owners"** and some of whom are not. And the end result of this reality is that more and more places either ban dogs outright (such as the city parks in Salida, an otherwise wonderful mountain town) or require them to be on leashes every minute of their lives (pretty much most of the rest of the state, with the possible exception of Leadville, which, true to its laissez-faire, live-and-let-live roots, seemingly has a town ordinance requiring that dogs be left to wander willy-nilly of their own accord).

Thing is, a high percentage of dog owners actually truly believe that their dog is trained. Given their dog's behavior, and their inability to affect that behavior, why dog owners think this is mystery. There are also lots of folks who are simply too unmotivated (read: lazy) to train their dog. There are even folks who argue, sometimes shockingly vociferously, that the process of training a dog irrevocably impacts the poor animal's true inner self, or its free spirit, or its chakra aura, or some such nonsense.

Here's the thing: We all live in the middle of this sometimes-ungainly beast called "society." Most of us would agree that, were we as humans to jump up on a perfect stranger with muddy paws, or were we to approach a stranger menacingly while growling, or were we to knock over someone's toddler at the park because we were running amok, a negative reaction would be justifiably forthcoming.

Why some people cannot understand that a negative reaction will likewise justifiably be forthcoming when their dog does any of these things is mystifying, especially when, as I said earlier, the result is an increase in dog-related regulations and, worse, bad blood toward dogs and dog owners.

*I understand that there might be aghast reactions by some of the more sensitive human companions at the use of the word "trained," which, in some circles conjures images that run counter to the cosmic-level blessed empathic relationship that is supposed to exist between enlightened members of the two respective species. Cesar Millan, of the *Dog Whisperer* fame, avoids such reactions by using the phrase "teaching your dog basic manners," much, he says, like a parent would teach his or her child basic manners. Since I consider the teaching of one's progeny to be a form of "training," I will forthwith use both terms interchangeably, with no offense meant to either canines or their human companions.

** OK, I know there are going to be folks who bristle at the use of "owner" or "owners" when used in reference to the relationship between human and dog. Thing is, there's only so many times you can use the words "human companion" without sounding like you're trying to gain social credence in Berkeley. Lighten up; you know what I mean. If you don't believe me, ask my dog.

More than that, though, by not training your dog, you are endangering your canine's very life. Many has been the dog that has been run over because its human companion was unable to prevent it from running into the street. Many has been the dog who has run off into the woods, never to be seen again, because it was not trained to stay within line of sight.

It is not an easy task to train a dog. Sure, it's easier with some dogs than others, but, by and large, it takes a commitment of time, energy, patience, and sometimes money. It also often requires an admission of ignorance, an admission that we simply do not know what we are doing, that we need to seek out expert input by way of a professional dog trainer or, failing that, we need to seek out dog-training videos and/or books, which are always good to peruse even if you are enrolled in dog-training classes.

But the reward is palpable and undeniable. With luck, you're going to have your dog for twelve to seventeen years. We have all witnessed scenes wherein despondent—and usually angry/frustrated/embarrassed—dog owners are trying mightily to get Bonkers to stop pestering other hikers and dogs on the trail, and Bonkers would be reacting with a haughty "screwyou, human," if only he had vocal cords and were he paying enough attention to his owner to even consider responding.

Flip side of the coin: It is a wonderful thing to be passed by Bonkers and his red-faced owners and to have them compliment you on the exemplary behavior of your dog as she sits obediently on the side of the trail, a compliment often followed by a statement like, "I sure wish we could get Bonkers to obey like that."

Thing is: You can! And you should. Matter of fact, you should be required by law to do so, the same way you're required to license your dog and get it rabies shots.

A lot of people might wonder where they can go to improve Bonkers's manners. Almost every town has a professional dog trainer. Sure, each trainer has his or her technique and quirks. Some advocate clicker training. Others have group sessions during which the dogs are not allowed to interact. Some prefer one-on-one classes. Some are nice to a fault. Some are too stern. But dog training is like going on a diet: It almost doesn't matter which one you choose. It matters that you're making a commitment to think about what you ingest. You are allowed to, and, if it is a good trainer, encouraged to put your own spin on the training of your canine.

I have gone through dog training with two different dogs. The first, Cali, ended up being one of the best-trained dogs I have ever seen, despite the fact that she was so unruly during doggie classes that I came to dread Friday evenings. The second, Casey—my current little bundle of squirming canine joy—well, not so much, though she, being a hardheaded little rascal, has turned out a lot better than I ever expected, and she's trained well enough that we still get a lot of compliments on the trail. Neither training process was easy. Classes last six or eight weeks, not counting the follow-up lessons that many dogs/dog owners require. Then, because, during classes, it's the owner who's being trained to train the dog, there are the required six ten-minute training periods per day. Then, there's the real-world refresher courses/practice

periods that should continue for the rest of the dog's life. The benefits deriving from that effort are without compare.

## Some salient observations

- First, if you are reading this book, there's a good chance you spend time out in the mountains with your dog. These observations, while certainly pertinent to those who live in and never leave their neighborhood in Omaha, are really tailored to a life outdoors. They are further tailored to a life where the dog is trained well enough that it can travel through the woods off leash***, though, of course, places where that is legal in Colorado are becoming rarer by the minute, at least partially because of irresponsible dog owners.
- Understand that it is your responsibility to teach your dog basic manners. It's not the responsibility of the people around you to tolerate your dog's bad behavior.
- Remember who is the member of the species with the supposedly superior intellect and who is a member of the species that eats cat shit. Though you will be using human words to communicate with Bonkers, it is you who will have to learn to speak dog rather than vice-versa.
- It is never too late to try to teach an old dog new tricks. And, more and more, dog trainers are saying that pups can begin classes shortly after they are weaned. Maybe this is a marketing ploy to get more money. Maybe not.
- Try to get a handle on your dog's disposition. Part of this will be based upon its breed, though that's no guarantee. Your trainer will be able you help you with this, but it's you who spends hours each day in your dog's company. A large part of how you go about training your dog will be determined by its temperament—whether it's hard or soft—and its motivation—whether it wants more than anything to please you (such was the case with Cali), whether it is motivated by positive reinforcement (usually taking the form of treats—otherwise known as "bribes"), or whether it is more motivated by negative reinforcement (sadly, the case with Casey, whose sole goal in life is trying to figure out what she can get away with).
- No matter which method of training you choose to pursue and no matter your dog's disposition and motivation, one of the most important things is consistency—in expectations (do not allow a certain behavior in some circumstances but not in others) and in the wording of commands (especially important if there are multiple humans in the pack; get everyone on the same page).
- One of the easiest ways to tell if a person has control of his or her dog is if that person has to yell to get the dog to obey commands and/or if the person has to repeatedly repeat commands. Neither should have to be done. Give commands in a neutral tone-of-voice and give them once. This is a lot harder than it might seem at first blush.
- A way to tell if a dog considers his or her human to be the alpha member of the pack—which is critically important to both the relationship and for the dog's psychic health—is if the dog

*** I fully get it that there are going to be many readers who become livid at the notion of anyone traveling with their dog off leash. To these people, I say: While I understand why you would feel that way, I hope you also understand why I prefer training my dog in such a way and to such a degree that I feel confident enough in Casey's behavior to travel sans leash.

frequently "checks in"—which can be as subtle as a glance or as overt as coming over to make physical contact. If the dog is not checking in with regularity, then there are issues with the dog's understanding of its place in the pack. This is something that MUST be rectified.

- Please resist the temptation to muck up other people's dog-training protocols. If you pass someone on the trail who has his or her dog on a sit/stay, do not call that dog over. I've had this happen many times, and I'll always say, "This is our protocol. She's not allowed to approach other people unless I give her permission to do so"—something, by the way, that's dog-training 101. Most people will apologize and then, sometimes, I'll "free" Casey to interact with those people. But some people just don't get it. They continue trying to call Casey off her stay and say something like, "It's OK; I don't mind." I have to clench my teeth and respond by saying, "Well, I do." I try to maintain a good mood by looking at this type of interaction as beneficial practice. I have also reacted to it by looking at the person-in-question and saying, "OK," then looking down at Casey, who is about as intimidating as a hamster, and bellowing, "Kill!"—while pointing to the by-now confused-looking person. Casey, for the record, translates the "kill" command to "lick." I have also reacted to people by saying that Casey's not all the way over her bout of rabies, but, hey, if they want to pet her, it's fine by me.

## Commands

- First understand that the exact wording of commands is not important. If you want to use "splorch" to mean, "sit," go for it. The dog doesn't know the difference. For example, with Casey, I use "wait" instead of "stay," for reasons I don't remember. Just make sure the other members of your pack speak splorch.
- Another big no-no is using your dog's name as a command synonym for "come." This can get your dog killed. A dog's name should be used to get the dog's attention. The command should follow the stating of the name.
- Use variable octaves to communicate your current attitude to your dog. Use a normal tone for basic issuance of commands. Use a higher-pitched tone when being playful with the dog to let it know it can relax. Lower your voice a couple octaves when you are trying to impart the attitude that this is serious, I am not screwing around, Bonkers, now drop that child!
- Though dogs certainly enjoy having their humans talk to them, remember that your lengthy explanations of why you are requiring them to obey you are not making much headway on the comprehension front and are likely muddling the situation. Keep it simple.

## Nonnegotiable commands

These are commands that your dog must know and obey without a nanosecond's hesitation, lest you find it necessary to assert your rightful place as alpha member of his or her pack.

- Sit. Weirdly enough, this most common of commands is usually ornamental, given in order for the dog to get a treat and before it shakes hands. It's still an important command because it generally precedes "stay."

- Stay. This is a tough one to teach, but critical.
- Free. You are now off stay.
- Come. It is surprising to observe how many dogs do not even twitch when this command is given. One important thing to note here is that, unless you dog has just maimed a child, resist whatever temptation you might have to discipline your dog when he or she obeys the come command. You don't want your dog to be scared to come to you.
- No. Simple and succinct, this command means that, whatever your dog is doing at the moment—short of breathing—needs to stop right this exact instant. Especially useful if your dog has a habit of lifting his leg on people's feet at the dog park.
- Lay down. I use this a lot when Casey gets a cactus needle in her paw.
- Drop. It doesn't matter if your dog has a steak that you just gave him or her (actually, that's a good way to teach this command), when this command is given, the jaws need to unhinge and whatever is in the mouth needs to fall from the mouth. This is another of those commands that might save a dog's life.
- Heel. Literally, walk with your nose next to my (usually left) heel.
- Back. Walk behind me. This is a trail command, because many trails are not wide enough for a dog to walk on heel.
- Go. If your dog is inclined to walk ahead of you in the woods, like both Cali and Casey, this means, "get moving pronto." Especially useful when you're skiing or mountain biking and there's a chance you could overtake your dawdling, sniffing cur.
- Sit/stay at a distance. This one takes work, but it is very important to be able to tell your dog to sit and stay even if it is separated from you by whatever distance. Most dogs will be inclined to come to you when you tell them to sit and stay because that's where most sit and stay training takes place. If Bonkers, say, has crossed a street, you do not want him to come to you. You want him to park his soon-to-be-yelled-at ass right where it is until you can come get him and safely return him to the correct side of the street. I have had a couple close encounters with rattlesnakes where my dog has wanted to come closer to eyeball the object of my immediate attention. You do not want your dog to do this.

## Loose commands

I have series of commands I define as "loose." Casey still has to respond to them, but they do not require the same immediate and absolute response as the nonnegotiable commands.
- Too far. This means, not surprisingly, that she is too far ahead of me on the trail, usually to the point where I can no longer see her and, thus, protect her from a predator or from running off a cliff. This loose command just means for her to slow down.
- Where's Casey? I ask this question when she's carousing through the woods or is someplace on my property that I can't see. This means that Casey must reenter my line of sight and make eye contact.
- Let's go. This is mostly used when Casey is on a sniff-a-thon and lagging behind.

- This way. This is used primarily at trail junctions when she, yet again, has chosen the wrong way.

## Basic manners

Whether you are a dog owner or not, each of us has had experiences while out in the woods where three monster mutts come running toward you full blast, teeth bared and saliva trailing behind them like a rooster tail. The owner, who obviously has no control whatsoever over his dogs, yells something lame like, "Don't worry, Cujo, Fang, and Warg are friendly." In the meantime, your dog has a look on his or her face like, "Heaven help me."

My wife has developed a decent response to this situation by saying, "Well, my dog isn't." Or, if Casey's cowering too obviously for this to work, she says, "Well, I'm not."

We'd like to think that either of these will leave some mark on the irresponsible owner, but, let's face it, they usually don't. They may shame the person that one time into trying to restrain his out-of-control dogs, but it likely won't make a lasting impression. Some people are simply in their own little world. The question then is: How to react to that?

I choose to react to that by insisting that Casey go through life displaying good manners. When we pass people on the trail, we stand off to the side and I put her on a sit/stay loud enough that the passing person/people can hear me do so. If their dogs are out of control, I get between Casey and their dogs and say something like, "She gets a bit nervous when confronted with blankety-blank out-of-control dogs." If the person says words to the effect of, "My, what a well-behaved dog you have," I respond by saying, as I indicated earlier, "It takes effort on the part of the human." If the passing people obviously don't care that their dogs are out of control and that the person they are passing—the one with the well-behaved dog—is obviously miffed, then stoic maturity is required: Rather than throwing a rock, I merely call that person an asshole.

Then there are the worst-case scenarios, the ones where out-of-control dogs attack you and/or your dog. This has happened to me several times. At that moment, all bets are off.

Here's the thing: We can't control the actions and attitudes of others; we can only control the actions and attitudes of ourselves and hope that our attentiveness rubs off.

Either way, the happiest of relationships between man/woman and dog are those where the communication is clear, where the dog knows the expectations placed upon it as a member of the pack, and adheres to those expectations. Once that is established, the business of going out into the mountains together and having fun becomes so much easier.

—M. John Fayhee

▲ Tanaya on Dolores River, 2011. Proud parents Karl and Kelly Kamm. ◄ Rodeo's best hiking advice: "Stay cool, don't worry about dirt, attitude conquers altitude, and make the best of every situation." Tenderfoot Mountain, Summit County. Human companions: Diane and Mike Smith. Photograph by Diane Smith. ▶▲ Neko along the Slate River in Crested Butte. Neko had spent the morning chasing birds and butterflies with little success, but she had just learned to high five. Photo by human companion Noah Koerper. ▶▼ Kenai cools off near the summit of Castle Peak before skiing back down to the lake (1,000 feet below) with her human companions, Erin and Frank Witmer.

# most
# satisfied

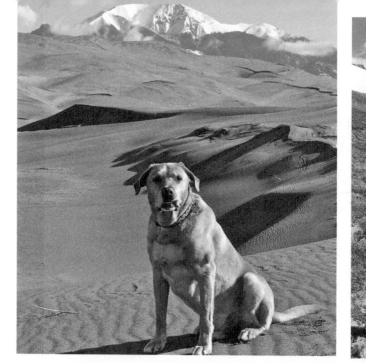

**TOP** Sam's official name is "Sam B. A. Oxford," with the "B. A." standing for "Beef Ass." Human companions Jeanne and Tom Montross picked him up from a small farm in Wetmore and he came with AKC papers, which Tom and Jeanne had no interest in, but they filled them out anyway. After perhaps a few too many cold beverages, it was decided that a dog with actual papers required a regal name. Tom took this photo of Sam, now thirteen, at the Great Sand Dunes National Park. **BOTTOM LEFT** Cooper in a wildflower meadow on Engineer Mountain outside Durango. Human companions are Peggy and Kyle McCracken. Peggy took the photo. **BOTTOM RIGHT** Brothers Junior (left), whose human companions are Ryan and Cindy Tammaro, and Wally, whose human companion is Rick Fruend—the photographer— were both born and raised in Breckenridge. Here, they pose after enjoying a swim at Upper Mohawk Lake during a killer cutthroat bite!

**TOP** Mally was named after George Mallory. Human companion Terry Hall got him right after the summer that Conrad Anker found Mallory's body on Everest and the story was on the cover of every outdoor magazine for months. Mally was a Rottweiler-Lab mix born in Vail in October 1999. The first day Hall had him, he spent the evening on a barstool at Cassidy's Hole in the Wall. For the next thirteen years, Mally hiked, biked, skied, camped, swam, and ran all over the Colorado Rockies, as well as visiting many mountain bars. The picture is from the 4th of July backpacking trip in 2004 up the Williams Fork over the Divide and back down the next drainage. **TOP RIGHT** After getting August from the Boulder Humane Society, human companion Matthew Fritz decided to take her to Montana to visit friends and family. One day, Fritz took August to Hyalite Lake and let her run around and experience lake water for the first time. On that day, her status as a mountain dog was set in stone. **BOTTOM** Bernese mountain dog Lola at St. Mary's Glacier with human companions Chris Budish and his daughters Abby and Tia. Photo by the fifth member of the Budish pack, Kristi.

▲ The mighty Cosmo is a silver poodle/doodle (purebred standard poodle) who looks down on other mixed-breed poodles (Labra/doodles, golden/doodles, etc.), but he's very bummed that he wasn't able to create a few new varieties himself before he was cut. Cosmo, who lives with human companion Greg Johnson in Edwards, loves spotting wild cutthroats in out-of-the-way places, like this secret spot in the Holy Cross Wilderness, but is just as happy wading a river or spotting from a boat. Of course ball is his first true love. ◄ Gnomie, born and raised on the Western Slope, bouncing into the snow on the doggie ski trail at the Aspen Cross Country Center trail system. Photo by Farland Fish.

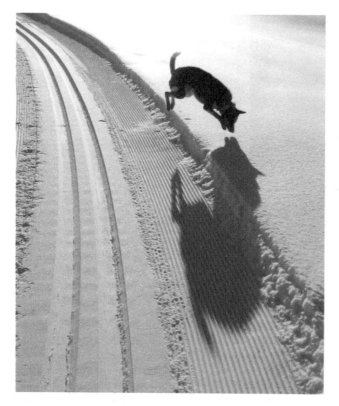

▶ Racer Ready Freseman came to human companions Carol and David Wedgwood, who live in Wildernest, via the Steamboat Springs Shelter. Though the Wedgwoods consider Racer to be the cutest and smartest dog in the whole world, she might not be the best squirrel hunter. ▼ Toby, adopted from the Boulder Humane Society, learned to love fishing as much as his people, helping prove that fishing nets aren't always necessary. Photo by human companion Jody Shepherd.

oh, great hunter

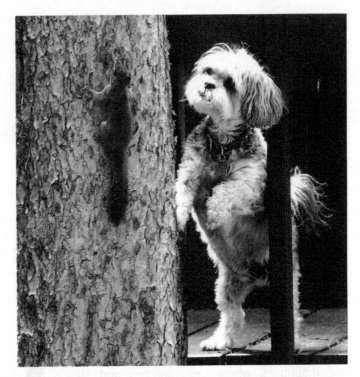

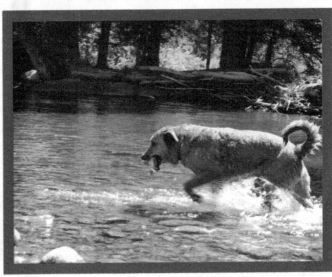

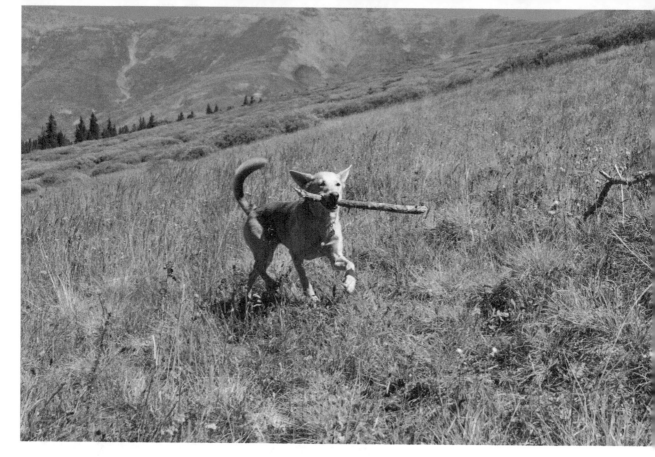

▲ Dharma is a stick connoisseur. She usually prefers "new" sticks straight off the tree. When high in the mountains, where trees are few and far between, she puts her expertise to use and still finds sticks that other dogs only dream of. Photo taken near Breckenridge by human companion Wesley Bond. ▶ Hawk ran into the shot with his stick just as his human companion, Tracy Olsen of Ridgway, was taking a picture of the Uncompahgre River down at the Ice Park in Ouray. For a minute there, she thought he was gonna jump! ▶▲ Nellie, whose human companions are Suzie and Steve Crase, at the Great Sand Dunes National Park, above Castle Creek. Nellie, a dedicated stick and tennis ball retriever, is following family friend Dean Baranski. Photo by Suzie Crase. ▶▼ Guinness chills in Dillon Reservoir, Summit County, while his human companion, Sterling Mudge, paddles.

# best schtick

**TOP LEFT** Heather enjoys a dip near Saints John. Photo by human companion Rich Boscardin. **TOP RIGHT** Sunshine Annie on patrol in the Puma Hills, hiking with her family, Tibby and Erik Beard of Colorado Springs. Annie is now five years old and has accompanied her family on many mountain hikes in Colorado. She was born in Black Forest and continues living in northern El Paso County. **BOTTOM** Ollie conquering a sketchy bridge on a treacherous Straight Creek on a raging spring melt day in beautiful Dillon. Ollie was rescued from a shelter in Orlando, Florida, by human companion James Wilson and was seriously stoked to move to the Colorado High Country. Photo by James Wilson (JWWfoto.com).

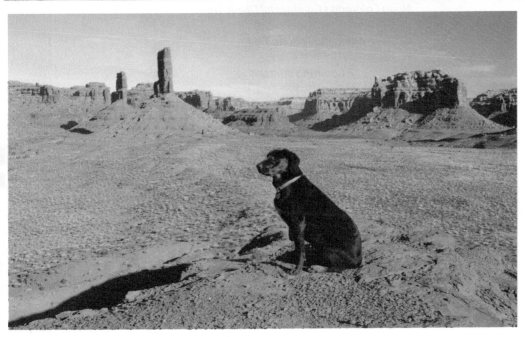

**TOP LEFT** Milo, a black Lab mix, was having trouble finding the stick on this particular camping trip. Photo by human companion Kimberly Wagner. **TOP RIGHT** Lil and Frodo on the way down from Mt. Sherman. Photo by human companion John Rath. Their other human companion is Brigitte Rath. **BOTTOM** Luna in the Valley of the Dogs, Utah. It was a real pain in the ass for her human companion, Rob Fillmore, a professor of geology at Western State College in Gunnison, to get her attention from all the little furry mammals that were scurrying around. But, he did. Eventually.

# Also By
# M. John Fayhee

*Mexico's Copper Canyon Country*

*Along the Colorado Trail*

*Up At Altitude: A Celebration of Life in the High Country*

*Along Colorado's Continental Divide Trail*

*Along the Arizona Trail*

*A Colorado Winter*

*When in Doubt, Go Higher: A Mountain Gazette Anthology* (editor and contributor)

*Comeback Wolves* (contributor)

*Bottoms Up: M. John Fayhee's Greatest Hits from the Mountain Gazette*

*Smoke Signals: Wayward Journeys Through the Old Heart of the New West*

*The Colorado Mountain Companion: A Potpourri of Useful Miscellany*

*From the Highest Parts of the Highest State*

CPSIA information can be obtained at www.ICGtesting.com
Printed in the USA
BVOW10s1548220514

354115BV00001B/1/P